MEXICAN ART
MASTERPIECES

MEXICAN ART
MASTERPIECES

Marcus B. Burke

HUGH LAUTER LEVIN ASSOCIATES, INC.

Contents

Acknowledgments

A book as widely drawn as this one, on a subject so vast and deep, could not have been written without the assistance of many colleagues. I owe a particular debt of gratitude to Professor Mary Miller of Yale University, who kindly reviewed the entries on ancient Mesoamerican art and corrected a number of otherwise very embarrassing errors. Professor Miller's survey of Prehispanic Mexican art, *The Art of Mesoamerica*, is, in my opinion, the best available text on the subject, and I have relied on it heavily here. Similarly, I wish to acknowledge my colleagues in the preparation of the 1990 Metropolitan Museum exhibition, *Mexico: Splendors of Thirty Centuries*, which covered much the same territory as the present text. The essays and catalogue entries that Johanna Hecht, Donna Pierce, Roberto García Moll, Elizabeth Hill Boone, Cristina Esteras Martín, Fausto Ramírez, Xavier Moyssén, Jacinto Quirarte, Sabine Rewald, and myself prepared for the Metropolitan Museum publication have been of inestimable value here.

I would also like to acknowledge general debts to Linda Bantel and Guillermo Tovar de Teresa, my colleagues in previous studies of colonial art. With regard to twentieth-century art, I had the advantage of consulting the works of Dawn Ades, Stanton Loomis Catlin, Erika Billeter, Hayden Herrera, Edward Sullivan, Alicia Azuela, and Shifra Goldman, among the others cited in the suggestions for further reading.

A particular hurdle for anyone publishing on Latin American art is the acquisition of photographs. On behalf of Hugh Lauter Levin Associates and myself, I want to express gratitude to Virginia Armella de Aspe of the Pinacoteca Virreinal and Héctor Rivero Borrell of the Museo Franz Mayer for their intervention on our behalf. Carlos Alcázar Solis provided useful images, and we are further grateful to the reproductions staff of the Instituto Nacional de Bellas Artes. The photographic and editorial departments of the Metropolitan Museum of Art were extremely helpful, as were our colleagues at Art Resource. In particular, we owe a massive debt to the Latin American Department of Sotheby's New York and to the Mary-Anne Martin/Fine Art gallery for providing numerous images, without which it would have been impossible to publish. Carolyn C. Risman of Sotheby's offered specially valued services in locating transparencies —far beyond the call of duty.

I also want to thank Margaret Connors McQuade and my other colleagues at The Hispanic Society of America and especially Mitchell Codding, the Society's director, for their support and encouragement. My heartfelt gratitude also goes to my neighbor, John Archibald, and to my wife, Lenka Pichlíková, both of whom have helped in ways going far beyond scholarship. Finally, I wish to thank my editor, Jeanne-Marie P. Hudson, for her patience and persistence, especially in the many frustrating moments we have had acquiring photographs. If this book excels in any way, it is largely due to her efforts.

Introduction

Few nations can claim an artistic heritage as ancient, rich, and varied as Mexico's. For over 3,500 years, Mexico has produced monumental art at the highest level of quality. This artistic tapestry is not merely the result of imported values and foreign conquest; at every step, Mexicans have developed an art that is recognizably theirs and undeniably great.

To understand Mexican art, it helps to know Mexican geography. Today, Mexico sweeps out of the northwest like some giant cornucopia, making a sharp left turn, then continuing northeast into the Yucatan peninsula, the boundary between the Gulf of Mexico and the Caribbean. Two immense mountain ranges, called the Sierra Madre Oriental and the Sierra Madre Occidental (the East and West "Mother" Ranges), divide the main part of the country into central plateau versus lowland coasts. To the north, deserts and mountains south of what the United States calls the Rio Grande form a barrier to easy settlement. To the south, the two Sierras join before the terrain plunges to the Isthmus of Tehuantepec, a north-south corridor of tropical lowlands running from the Gulf to the Pacific. As a result, communications are much easier north-south—along the Isthmus, along the coasts, within the central plateau—than they are east-west.

Mexican history suggests the larger divisions of Mexican art. First comes the Precolumbian, or Prehispanic era, from the beginnings of indigenous civilizations down to the arrival of the Spanish and the fall of Mexico Tenochtitlan in 1521. The subsequent period is of course the Colonial era—or as the Mexicans would prefer to say, the Viceregal era, after the fact that Mexico was then governed by a series of viceroys appointed from Spain and officially called "The Viceroyalty of New Spain." Although the Viceregal era officially lasted until the coming of independence in 1821, the art historical break came a

bit earlier, around 1780–1790, with the arrival of the Neoclassical and Romantic styles and the establishment of the Fine Arts Academy of San Carlos in New Spain. By 1821, the early modern era was an established fact, and its values persisted until the Mexican Revolution and civil wars of 1910–1921. Thereafter, we speak of "modern art" in the sense of twentieth-century art, beginning with the muralist movement and the avant-garde of the 1920s and 30s.

Prehispanic Mesoamerica. The Prehispanic era has traditionally been divided into three periods, called the Formative (1500 B.C.–A.D. 100/200), the Classic (A.D. 100/200–800/900), and the Postclassic (A.D. 800–1521). Originally, these were terms of convenience used by archaeologists to explain the position of a given culture relative to what were considered the benchmark cultures of ancient Mexico: Teotihuacán in central Mexico, Monte Albán in Oaxaca, and the various Maya centers in southern Mexico, Belize, Honduras, and Guatemala. We now recognize, however, that it was the Olmecs in the Formative period who set the initial standards for almost all subsequent Mesoamerican civilizations, and we use the word *Mesoamerica* (that is, upper Central America as opposed to North or South America) to indicate that the Prehispanic cultures affected a somewhat different geographical area than the modern Mexican Republic.

Who were the Olmecs? We do not know, at least in terms of their ethnic origins. The name derives from traders who were located on the Gulf Coast at the time of the arrival of the Spanish, who seem to have had no direct connection with the ancient Olmecs but, much later, inhabited the same stretch of tropic jungle coastline in the states of Veracruz and Tabasco. So many elements of subsequent cultures—pyramids, ball courts, the Mesoamerican calendar, the use of jade and mirrors, the use of dynastic portraits to establish authority, hybrid human-animal figures, a

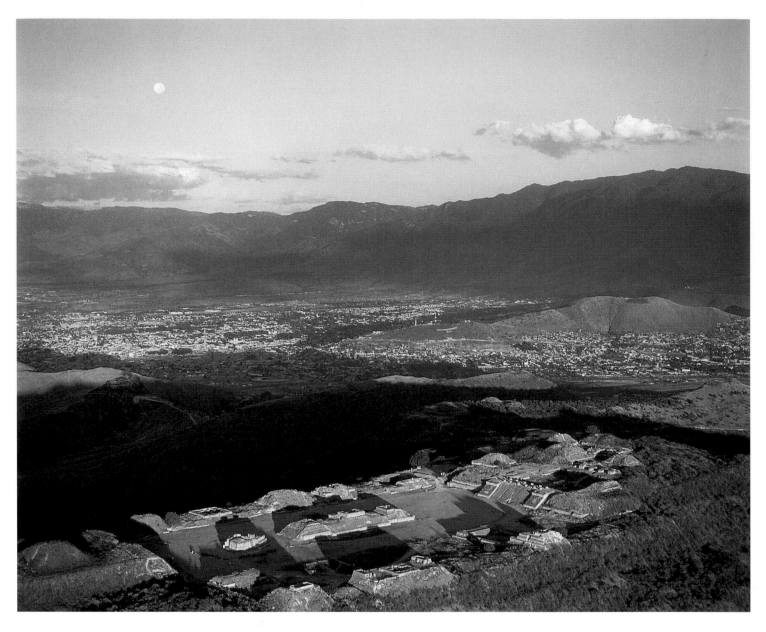

number of specific gods and heros—derive from the Olmecs that it is possible to speak of their culture as the origin of ancient Mexican civilization. Olmec art is monumental, with huge stone heads among the earliest products, but it is also lively, humanistic, and sophisticated.

Monte Albán and Veracruz. Olmec achievements spread with difficulty over the mountains to the west into central Mexico, with more ease south along the Isthmus of Tehuantepec into Oaxaca, and also east and southeast into the various Maya regions. One direct connection was with Monte Albán in Oaxaca, where both Formative and Classic periods were included in some 1500 years of development (600 B.C.–A.D. 900) under the Zapotecs. Interestingly, there is a gap of several centuries in the Gulf Coast before the development of the Classic period culture centered on Veracruz (A.D. 300–1000), but it is clear that many local values were preserved. Veracruz Classic architecture is particularly rich, as in the

example of the Pyramid of the Niches at El Tajín, where the niches decrease in size on each successive storey, and a type of perspective is employed to augment the illusion of height.

Teotihuacán. All ancient Mesoamerican centers pale in comparison to Teotihuacán, a huge metropolis with more than one hundred thousand inhabitants that flourished between A.D. 150 and its destruction in 650. (Its culture survived in other centers until about 900.) In addition to two of the largest pyramids ever constructed, Teotihuacán boasted an enormous ritual center (including a temple dedicated to the rain god, Tlaloc, and the plumed serpent, Quetzalcóatl), palaces, markets, and neighborhoods with foreign ethnic groups. Most of the public buildings were elaborately decorated with frescoes or polychromed sculpture. In almost every possible way, the art, culture, and religion of Teotihuacán set the tone for central Mexican civilization, with subsequent cultures down to the Aztecs coming to pay homage to its

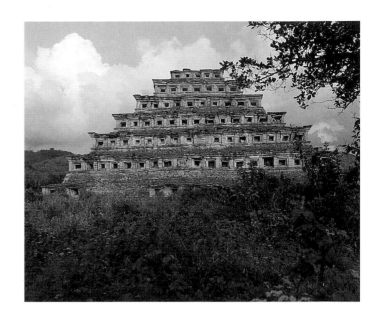

(Opposite) View of Monte Albán, Oaxaca. Photograph: Michael Calderwood/Ami/Art Resource, New York.

(Top, right) The Pyramid of Niches, El Tajin. Photograph: Werner Forman/Art Resource, New York.

(Below, right) Teotihuacán, The Pyramid of the Sun with the Pyramid of the Ciudadela in the foreground. Photograph: Werner Forman/Art Resource, New York.

splendid achievements. Indeed, Teotihuacán's influence was ubiquitous throughout Mesoamerica, driven in part by an agressive trade policy.

The Maya. While Teotihuacán was massive, classic, and centralized, after the manner of Rome or Constantinople, Maya civilization flourished at scores of centers, as did Greek and Italian Renaissance cultures in their city-states. Just as we can speak of Italian Renaissance art without implying political unity, so can we speak of Classic Maya culture (A.D. 300–900) as a whole while revelling in its rich diversity. The Maya had common myths and gods, a universal system of writing with glyphs (picture symbols), similar architectural and sculptural conventions, and a great deal of trade and cultural interchange among centers. Maya achievements in calendar writing, astronomy, architecture, medicine, and the arts are astounding, as the rare beauty of the objects illustrated here attests. Yet they never quite escaped their tribal origins, maintaining a high level of regional violence, which eventually escalated into wars of conquest contributing to the progressive decay of the civilization as a whole. Because there was no imperial center, the end was not sudden. Instead, the lights gradually went out one by one in succession roughly from southeast Mexico and Guatemala into northwest Yucatan, where the early Postclassic Maya culture at Chichen Itzá was reinvigorated in 986 by Toltec invaders from Tula in central Mexico. Tula was destroyed in the late 1100s, and Chichen Itzá fell into decline in the 1200s.

The Aztecs. The history of central Mexico in the Postclassic period is a tale of unrelenting barbarian invaders from the north, including the ancestors of the Toltecs and the Aztecs. If we think of the Mycenean Greeks invading Minoan Knossos, only to be displaced themselves by the Dorian Greeks, or of the waves of barbarian tribes pouring into the late Roman Empire from eastern Europe and central

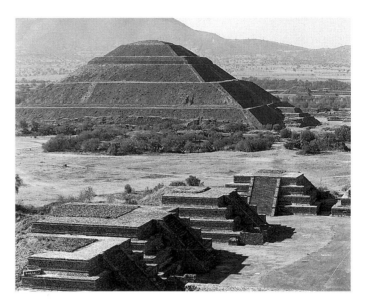

Asia, we get some idea of the Postclassic situation. The Aztecs were originally rather minor players in this drama, until a divine sign from the tribal god Huitzilopochtli—an eagle on a cactus, devouring a serpent, which is still the national symbol of Mexico—led them to establish their capital amid marshy islands in ancient Lake Texcoco around A.D. 1345. This city, Mexico Tenochtitlán, grew in importance until it dominated the areas around the lake, and by the 1400s it commanded an empire stretching from the deserts of the north into Guatemala.

The Aztecs were an intensely martial culture whose principal cult, the worship of Huitzilopochtli (associated with the sun), was both an effective stimulus to successful imperialistic wars and a remarkably bloody affair demanding constant human sacrifice. While many world cultures (Rome and China, for example) have sacrificed captured enemies, the Aztecs inverted the practice, staging what they called "flower wars" in order to obtain sacrificial victims. They seem to have

11

convinced themselves of the necessity of constant war and blood sacrifice as a condition for the gods' maintaining the existence of the universe. This perverse situation, along with the Aztec's recent arrival on the Mesoamerican stage, led to an extremely shaky empire and permanent cultural insecurity. The Aztecs sought to appropriate the arts and culture of previous civilizations, beginning with the Toltecs and Teotihuacán, both as a basis for their own new culture and as a means of validating their political dominance. They had just reached a plateau in this artistic endeavor—what the scholar George Kubler called the Aztec imperial style—when the arrival of the Spanish brought an end to the entire ancient Mesoamerican world.

The Viceregal Era. After the initial conquest of central Mexico in 1519–1521, the Spaniards began the double task of bringing the new territories and their inhabitants under Spanish administration and converting millions of indigenous Mexicans to Christianity. (It has often been said that the true "conquest" of the New World, in cultural terms, was effected by the friars who replaced the Prehispanic religions with the new Judeo-Christian faith.) By necessity, however, the friars had to find elements that the old and new religions had in common. Similarly, in political terms, the Spanish, who were intially a tiny minority in the new colonies, had to rely on native Mexican allies, both to conquer the Aztecs and to govern after the central Aztec power was broken. Thus, demographics, political and economic reality, the missionization process itself, and an attempt on the part of some friars (particularly the Franciscans) to turn their missions into utopian social experiments all combined to create a hybrid culture in the first century of the colony.

As the images from codices (manuscript books) and feather mosaics illustrated here attest, the hybrid indigenous-European works of art produced in six-teenth-century Mexico are often rare and wonderful indeed, but the "Indo-Christian" style, as this type of art is called, was doomed. The humanist values of the friars and the sincere desires of many Spaniards to create a just society in New Spain were countered by the greed of many of the conquistadores and their descendants. The sources of wealth in the viceroyalty—agricultural land and mines—were only valuable to the extent labor was available, and working-class Indians were therefore ruthlessly exploited, often with the cooperation of their own leaders, to build the wealth of the colonists. Worse, the native population had little resistance to European diseases such as smallpox and measles; millions died in epidemics in the late 1500s. At the same time, European immigration, especially into urban areas, continued unabated, so that by about 1600–1620, European cultural domination at the centers of power was nearly complete.

What happened to the hybrid, Indo-Christian art of the sixteenth century? It of course continued to be produced, but on the fringes of colonial society. Only in a few regions, such as Patzcuaro Michoacán, Oaxaca, and areas south of Puebla, where the indigenous patron class remained powerful, did monumental hybrid forms resist Europeanization. In general, however, the Indo-Christian style merged into what is called "folk art." This is not to say that it fell into decay, for Mexican folk art can claim its place among the most important artistic expressions of world culture. As deserving as it is of its own treatment, the history of Mexican folk art is not the story told here. Our tale concerns art at the centers of viceregal power, that is to say, in the large urban regions of Mexico City, Puebla, Querétaro, and even at the increasingly Europeanized Oaxaca of the late seventeenth and eighteenth centuries.

The symbols of the new European domination in the viceroyalty were the great cathedrals erected in Renaissance style all across Mexico during the 1600s.

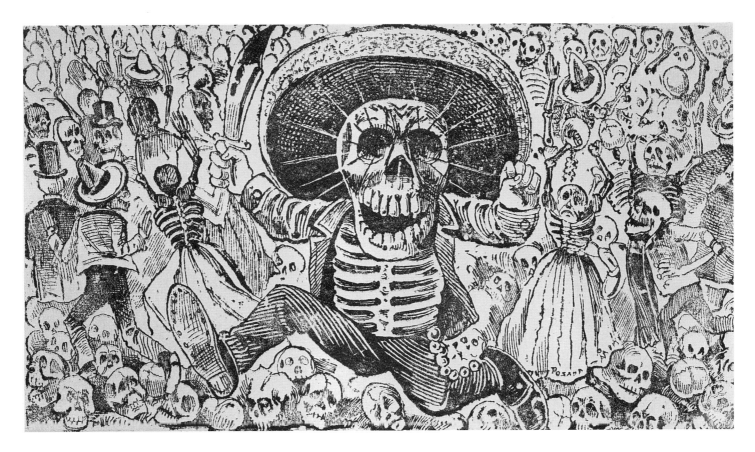

Puebla's cathedral was finished in the 1640s, Mexico City's, after initial attempts in the 1620s, was delayed by disasterous floods and not completed until the 1670s. Unlike the churches of, for example, Cuzco in Peru, where the ancient Inca building stones still call attention to themselves on the facades, the Mexican cathedrals completely obliterate the Prehispanic sacred precincts, as in the case of Mexico City, where herculean excavation projects have been necessary just to reveal the foundations of the Aztec temples. Social issues also intervened: for example, the Mexico City painters' guild, founded by immigrants in 1557, was free of overt racial impediments but just as clearly enforced European artistic values. After the Council of Trent (1545–1563/64), the spirit of the Counter-Reformation urged a universal, Eurocentric orthodoxy upon the Roman Catholic Church around the world. Counter-Reformation (also called Tridentine) Catholicism became a constant presence during the entire colonial period.

At the same time, the European-dominated society of New Spain was not simply a copy of that left behind on the Iberian peninsula. Quite apart from the continued interaction with the (now hybrid) folk culture, viceregal society represented a wide array of international influences. The Spaniards arriving in Mexico were themselves, for the most part, from the periphery—Extremadura, rural Andalusia, the Basque country—and they were joined by immigrants from other areas of the Spanish empire, particularly the

low countries. Among the "founders" of the European-dominated Mexican school, we find the Basque Baltasar de Echave Orio (c. 1558–c. 1620) and the Netherlander, Simon Pereyns (in Mexico 1566–1589), both of whom worked in a reformed Mannerist style.

What is more, trans-Pacific commercial links via Manila in the Philippines brought in Oriental influence, particularly notable, as we shall see, in the decorative arts. More importantly, Mexicans of European descent, called Creoles, quickly began to think of themselves in autonomous cultural terms. For example, within the Counter-Reformation church, Mexican Creoles and *mestizos* (people of mixed race) took up the cause of what had originally been an Indian devotion to the Virgin of Guadalupe at Tepeyac, a hill near Mexico City, obtaining for themselves an indigenous Mexican, non-European, but completely orthodox focus to their Catholicism. By the last decades of the seventeenth century, Creole nationalism at Mexico City would sponsor the development, in artists such as Juan Correa (c. 1646–1716) and Cristóbal de Villalpando (c. 1645–1714), of an idiosyncratic local style entirely distinct from that found in Spain at the same time.

The eighteenth century found Mexico in the midst of a long-lived economic expansion, driven in part by the second silver boom. Although the school of Mexico City in fact returned to European artistic

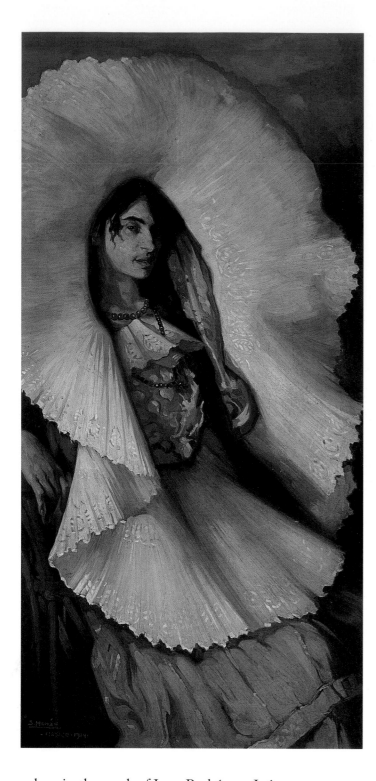

(Left) Saturnino Herrán (1887–1918). *Woman from Tehuantepec.* 1914. Oil on canvas. 59 x 29 ½ inches (150 x 75 cm). CNCA-INBA Instituto Cultural de Aguascalientes, Museo de Aguascalientes. Photograph © 1990 The Metropolitan Museum of Art, New York.

(Opposite) Juan O'Gorman (1905–1982). *The Colonial Past.* 1952. Mosaic on the facade of the Central Library at the Universidad Nacional Autonoma de Mexico, Mexico City. Photograph: SEF/Art Resource, New York.

The Nineteenth Century. Modern art begins one generation before the coming of independence, with the founding of the Fine Arts Academy of San Carlos in New Spain in the mid-1780s. Although sufficient numbers of native-born Mexican artists were capable of working in the new Neoclassical manner, professors were imported from Spain, particularly from Valencia, and large-scale projects were undertaken as expressions of enlightened artistic and cultural policies. After independence was finally achieved in 1821, the Academy provided much needed continuity with the past and a means of access to European art, including training and artistic prototypes, not to mention a focus for patronage in an era lacking both a strong central authority and an empowered church hierarchy.

At the same time, the economic decentralization of the eighteenth century was greatly augmented by political decentralization after independence, so that local patronage and local values become increasingly important in nineteenth-century art. Similarly, the new Romantic interest in folk art and the increased relative importance of at least middle class commoners in the new republic insured the dialogue between the so-called "fine arts" and popular expressions. The work of Hermenegildo Bustos reproduced here is a good example of how a provincial master of genius, while relatively unsophisticated from an academic point of view, could nevertheless find significant local patronage. In the context of the popular press, the graphic artist José Guadalupe Posada (1852–1913) produced images drawing on folk traditions, including those of the Day of the Dead (the Mexican equivalent of Halloween), in the context of political and social satire. Posada had an important influence on the first generation of Mexican modernists.

The Twentieth Century. The final decades of the nineteenth century saw Mexico making technological and industrial progress under the dictatorship of

values in the work of Juan Rodríguez Juárez (1675–1728), José de Ibarra (1688–1756), and Miguel Cabrera (1695–1768), Mexican colonial art in general experienced a renewed dialogue with folk art. New regional economic power supported regional styles, especially in architecture and church interiors, and the buying power of an immensely rich society produced new secular subjects in art, as well as extraordinary examples in the decorative arts. A new type of genre, called *castas* paintings, arose in the eighteenth century to celebrate the various mixtures of races and cultures in the viceroyalty; Juan Rodríguez Juárez and Miguel Cabrera made important contributions to this new type of art.

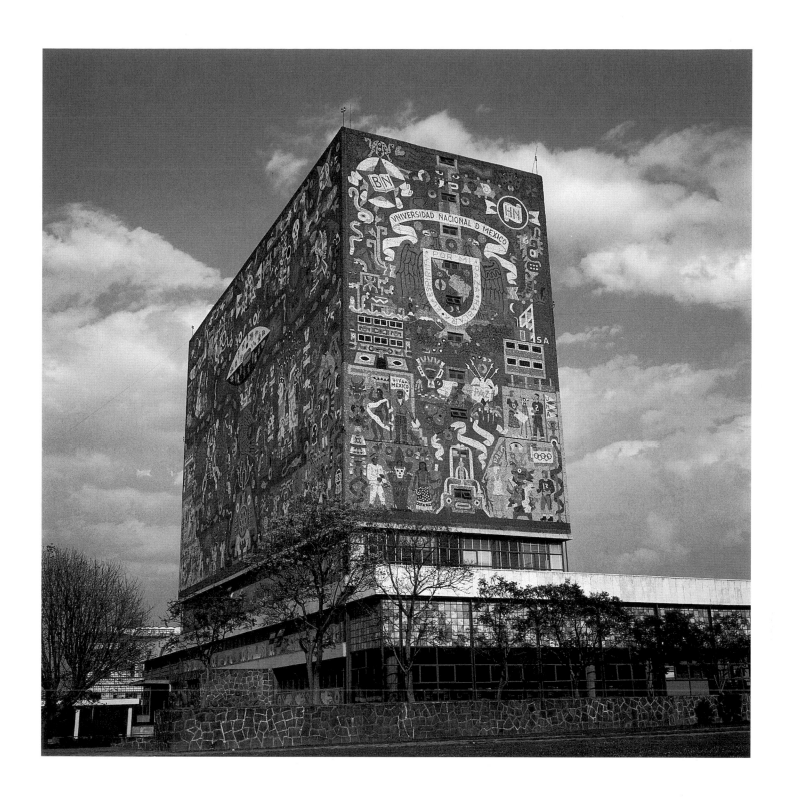

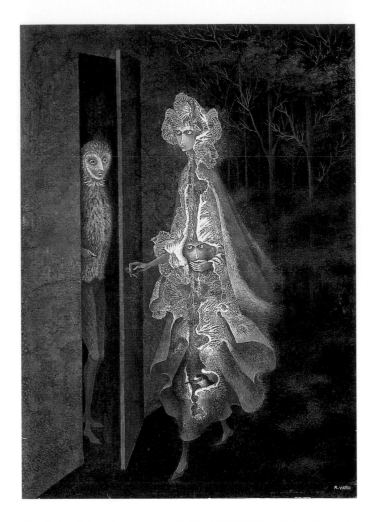

(Left) Remedios Varo (1908–1963). *The Encounter*. 1962. Oil on canvas. 25 ¼ x 17 ¼ inches (64 x 44.5 cm). Private Collection. Photograph courtesy Christie's Images.

Porfirio Díaz (in power 1876–1910/11), while the relative economic situation of workers, and especially, of agricultural laborers, steadily worsened. In 1910, liberal elements among Mexico's leaders began to rebel, ushering in a decade of revolution and civil wars that only came to an end in 1911. It was against this background that proto-Modernists such as Saturnino Herrán and Dr. Atl, not to mention the young David Alfaro Siqueiros and José Clemente Orozco, developed their new styles. Other Mexicans, such as Diego Rivera (as well as Siqueiros and Orozco on several occasions), found it useful to be in Europe or the United States. The revolutionary period left a number of legacies to Mexican Modernism. The first was a union of avant-garde art and radical politics that would continue to dominate into the 1940s. The second was a sense of a wider public—art was created for all citizens, not just for a bourgeois elite. There was a concomittent openness to folk art and a desire to bring indigenous subjects to the center of artistic endeavor—a movement called *indigenismo* that may be found throughout Latin America. Finally, Rivera's stay in Paris and participation in early Cubism meant that Cubist compositional techniques and the general example of Pablo Picasso would continue to be of prime importance for Mexico throughout the twentieth century.

The Mexican avant-garde was also lucky to find an influencial patron in José Vasconcelos, who came to power as minister of education with Alvaro Obregón in 1920–1921. In 1922, Vasconcelos began a project of mural decoration that eventually affected Rivera, Siqueiros, Orozco, and their slightly younger contemporary, the architect and muralist Juan O'Gorman (1905–1982). Muralism, with its implied mass audience, therefore became the cornerstone of Mexican Modernism, the benchmark against which other tendencies were measured. As the art of Carlos Mérida and Rufino Tamayo proves, there were other, more personal ways for Mexicans to express themselves. We would also be remiss if we did not note an extremely important element in Mexican art from the 1920s on: the influence of Surrealism. In addition to the Surrealist elements in the art of Rivera, Siqueiros, Mérida, Tamayo, Kahlo, Izquierdo, Ruiz, Toledo, and Zenil, one can cite the more purely European Surrealism of artists such as Leonora Carrington (born 1917) and Remedios Varo (1908–1963), whose other-worldly, dreamlike images have found a wide following.

With so long and rich a tradition to survey, it is difficult to offer any one summary of Mexican art that would not omit or compromise some aspect of this glorious 3,500-year history, at once exotic and familiar, intimate and monumental, dynamic yet imbued at many points with the most exquisite sense of classical design. Perhaps the best course would be to turn to the works themselves and let them tell their own exciting story.

Marcus B. Burke, Ph.D.
Curator of Paintings
The Hispanic Society of America
New York

MEXICAN ART
MASTERPIECES

Figure of a Man (called "The Wrestler")
c. 1500–900 B.C.
Olmec

Basalt. Height: 22 ½ inches (66 cm).
Museo Nacional de Antropología, Mexico City.

Almost everything we have from the Olmecs is surrounded by mystery, and nowhere so clearly as in this magnificent figure. The assertive posture, the sense of tension in the arms and hunched shoulders, and the implied dynamism of this figure's pose all add up to one of the most lively figures in ancient art, New World or Old. But who, or what, was he intended to be?

One possibility is that he is an athlete, as the traditional title, "The Wrestler," implies. The Olmecs built ball courts at what seem to have been important locations in their centers, and we may assume that they held athletic prowess in the same high esteem as did subsequent Mesoamerican civilizations.

On the other hand, the beard and what remains of the weathered face suggest an older man, while the holes in the earlobes indicate that the figure may have sported circular jade earrings (called earflares). Many scholars feel that figures such as this were dressed in now-lost garments. Given the tension in his arms, he might possibly have held or been pulling a rope. At least one depiction—the so-called Altar 4 at La Venta—shows an Olmec ruler holding a rope attached to captives. The figure here may also represent a priest or shaman in the act of incantation, or perhaps a mythic hero acting out a long-lost legend.

He might even be a god, or a personification of a force of Nature, although such representations were often given symbolic or monstrous forms, like the Olmec "were-jaguars" or the gods of subsequent cultures. (A later exception is the maize god, who could be a handsome man.)

One thing is certain about the statue: it is old. We often assume that abstract art is more "primitive" and realistic, naturalistic art more "advanced," but as the noted scholar George Kubler pointed out, Mesoamerican art can move from naturalism into abstraction and back again according to a variety of influences. Indeed, The Wrestler and many other highly accomplished realistic human figures are dated to the Early Formative period, 1500–900 B.C., and all the much more abstracted figures that one thinks of as typical of ancient Mexico are younger. Although The Wrestler predates a much abstract art, technically it must be a product of considerable prior artistic development, which suggests that we may perhaps find even earlier treasures as archaeology progresses. To dismiss Mesoamerican culture as "primitive," therefore clearly overlooks the sophistication and artistic achievements of its oldest monumental artifacts, which are worthy of comparison to the best that contemporary civilizations such as the ancient Minoans, Myceneans, New Kingdom Egyptians, Babylonians, and Assyrians produced.

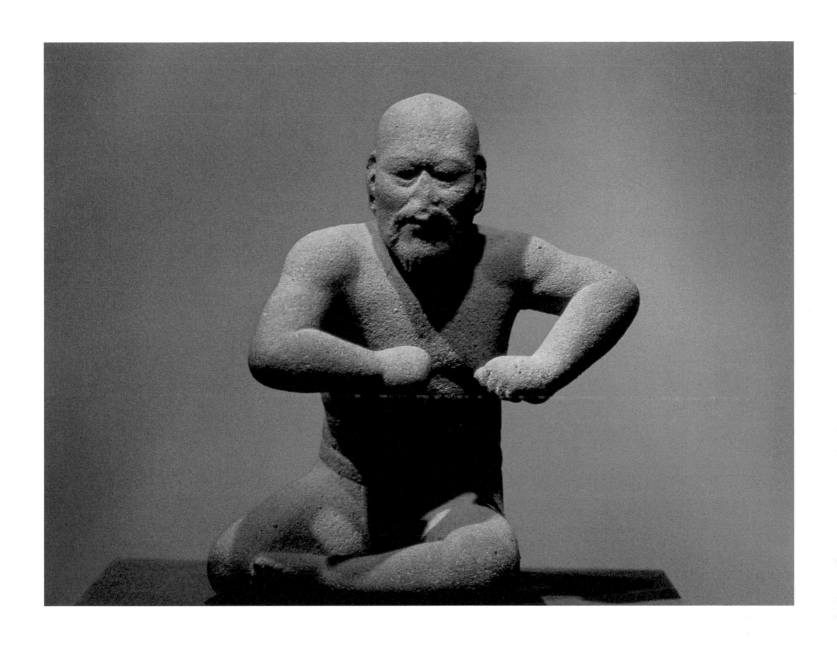

Jade Mask with Necklace
150–600
Classic Period

Teotihuacán, with later additions.
Greenstone, turquoise, and other semiprecious stones. Height: 7 ⅛ inches (18 cm).
Museo Preistorico ed Etnografico Luigi Pigorini, Rome.

The word "classic" is used in Western languages to describe a culture or style that establishes a type, sets standards, or first expresses what is quintessential in a civilization. We thus speak of the "classic" art of Greece and Rome, or even, on a less exhalted level, of "classic" motorcars and clothing designs. In the early years of archaeology, the term "classic" seemed to best describe the flowering of cultures in Mesoamerica (Mexico and Central America) from about A.D. 100 to 900. The ancient residents of Teotihuacán, like their contemporaries in Vera Cruz, Oaxaca, and the Maya states, seemed to early scholars to have achieved something akin to the accomplishments of the Ancient Greeks, and so this era was dubbed "classic," and was assumed to have set the benchmark for all Mesoamerican civilization.

Much new information has emerged in the past half-century, however, and we now accord the roles of progenitor culture and artistic benchmark of ancient Mexican art to the Olmecs, our respect for the achievements of Prehispanic civilization having grown to the point where it is no longer necessary to borrow glory from the Greeks, Romans, or any other European people. The term "classic" however, does imply a certain style, based on geometric forms and harmonic relationships and found in the art of the Greek Classic period (400s B.C.), of Rome, of the Renaissance, and of other European artistic movements, most notably (and logically) Neoclassicism.

With the art and architecture of Teotihuacán we can truly speak of a "classic" civilization. Heavy, monumental, emphatically geometric, the buildings of Teotihuacán were laid out on a strict urban grid arrayed along astronomically determined axes, with humanistically conceived palaces surrounding immense pyramids. Although destroyed in a violent invasion c. 650, Teotihuacán's culture remained dominant in the Valley of Mexico for at least two more centuries. Subsequent cultures, and particularly the Aztecs, held Teotihuacán in awe, making pilgrimages to the site and reverently collecting works of art.

Masks from Teotihuacán have no holes for breathing, and were presumably intended either for grave bundles or as the heads of ritual figures, perhaps intended to be dressed in ceremonial clothes. The "classic" simplicities of the underlying form of the mask, with the gentle curves of the spadelike face, the triangular nose and rectangular ears, convey a sense of permanence and well-being.

Teotihuacán masks are usually anonymous, generally humanistic in a way that allows their viewers to project their own, individual values onto the work of art. But this mask is somehow different, with its lively eyes and striking red meanders painted on the cheeks, not to mention the bright colors of the jade and turquoise mosaics. What has happened? The reason for this atypical vibrancy derives from the respect that the Aztecs had for Teotihuacán. At some point in the Postclassic era, an ancient greenstone mask was reworked—"updated" artistically—by the addition of mosaic inlays. (It is not clear whether the Teotihuacán original was also covered by mosaic.) The classic greenstone has thus become something a little bit gaudy, bright, and gay, but at the same time, even more hypnotically beautiful. As such, the object perfectly symbolizes Teotihuacán's gift to ancient Mexico: a solidly founded civilization, which no amount of barbaric invasion, imperial posturing, or latter-day materialism can obscure.

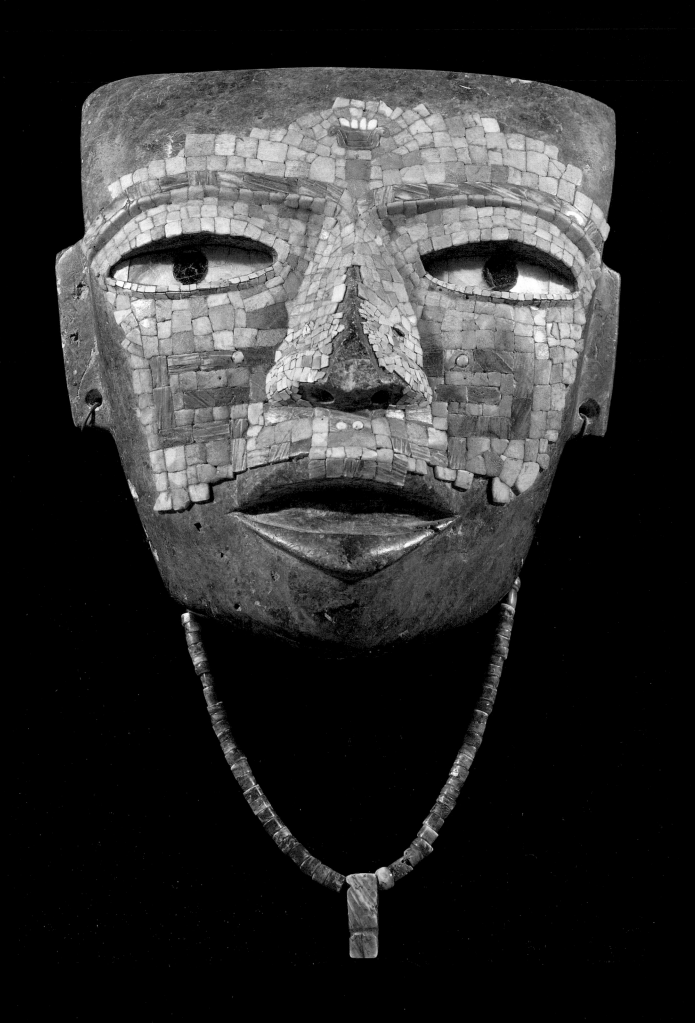

"Smiling Figure"
600–900
Veracruz Culture

From the Mixtequilla Region, Veracruz.
Ceramic. Height: 22 inches (55.9 cm.).
Michael C. Rockefeller Collection, Metropolitan Museum of Art, New York.

The art of ancient Veracruz never ceases to astonish. Located on the northern fringe of the Olmec heartland, Veracruz inherited many of the Olmec architectural and artistic traditions directly, which may explain the startling vivacity of many Veracruz sculptural details and ceramic objects. All too little is known about the people who built the large metropolis and ritual center at El Tajín that once covered 2600 acres and dominated numerous lesser centers. The Totonac group now populate the region, but whether the Veracruz culture was Totonac, Huastec, ancient Olmec, modern Olmeca, or some other ethnicity has not yet been determined.

We do not know from whom the people of Veracruz descended, but we do know a lot about their material culture. They cultivated cacao, cotton, and corn (maize), as well as natural petroleum rubber, which they used to make balls for their ritual ball game, a sport that brings to mind jai-alai, American football, and ancient gladiatorial contests. El Tajín itself was an Olympia-like center for the games, with at least eleven monumental ball courts. Like the Greek Olympic games, these ancient competitions at Veracruz, as well as in other Mesoamerican cultures, was ritual in intent and was associated at El Tajín with the cult of pulque, an intoxicating drink related to tequila, fermented from the sap of a type of agave plant.

Much has been written about Prehispanic culture on the basis of misreadings of Veracruz objects, the most blatant example of which was the idea that figures dressed in the ritual paraphernalia of the ball game were astronauts from outer space! What is more, not long ago, connoisseurs of Veracruz ceramic sculpture were shocked to discover that some of the most famous objects, including those in important museum collections, were in fact modern reproductions, possibly created and certainly marketed with the intent to deceive.

Nevertheless, when confronted with works such as the "Smiling Figure" exemplified here, it is tempting to project modern values onto the objects in keeping on the premise that human nature is constant throughout history. Indeed, these figures look like pop singers, microphones held slightly outward, right hands thrown up in the ecstacy of song and acknowledgement of an audience. The "microphone" is of course a gourd, and may well have been a rattle similar to those still used in Latin music, and ecstatic trances, induced by a variety of means, are still associated with both religious and secular music.

But there are other explanations for the "smiling" figures. The rattle, upraised arm, and the smiling/singing face may be those of a shaman or healer invoking spirits. Or, they may be the accoutrements of a specific ritual, including, possibly, something associated with the cult of pulque—the upraised hand is found in ancient pagan, Jewish, and Christian art on *orantes*, or praying figures—or perhaps a specific god or hero carried these attributes in ancient Veracruz myth. Whatever the answer may be, we like what we see and feel a kinship with those whose art continues to charm more than a thousand years after its creation.

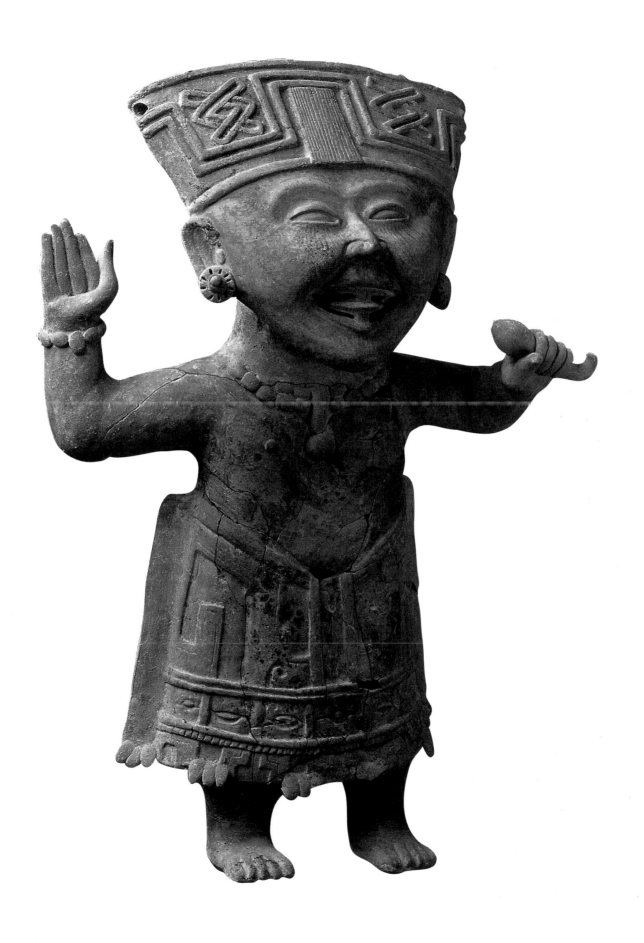

Funerary Figure (urn)

c. 300–600

Zapotec

From Monte Albán (IIIa), Oaxaca.
Painted ceramic. 20 x 21 inches (50.8 x 53.3 cm).
Private Collection, New York.

This spectacular object depicts a human face flanked by prominent earflares emerging from the mouth of an unusually naturalistic jaguar, the jaguar being a highly symbolic creature in the mythology of the Mesoamerican cultures. The face is itself surmounted by a small seated figure intertwined with serpents under what may be a rain god crest. The face and jaguar bear six cylindrical objects, three to a side, matching six more arrayed at the top above the serpent forms but in front of the plumes at the upper edge. These cylinders have been interpreted as corn cobs, but they are more likely snail shells *(caracoles)*, which are associated with the rain god Tlaloc in Teotihuacán imagery, as are feathered serpents. (Both the small seated figure and the triangular, protruding lip of the human face at the bottom also recall aspects of the Maya rain god, Chac.) The figure is possibly a variant of the Oaxacan rain god, Cocijo. At the lower left and right, the serpentine forms terminate in low relief profiles of jaguar knights.

Similar images, called urns because of their ceramic material and cylindrical core, have been found guarding the entries to tombs, such as Tomb 104 from the Early Classic (IIIa) period at Monte Albán, c. 300–600. If, as seems most likely, the present example was such a figure, it would probably have had a body and a base representing another Oaxacan deity.

The work is also evidence of Monte Albán's position as the center of the ancient Mesoamerican world. Connected to the former Olmec lands and the lowland Maya by the Isthmus of Tehuantepec, to the highland Maya of Guatemala and Honduras by coastal routes, and to Teotihuacán by both land routes and extensive trade, the peoples of ancient Oaxaca blended many diverse elements into their own artistic culture. The face on this funerary object clearly speaks of Teotihuacán, while the ceramic urn form or its analogue in stone is found at several Maya locations; we may also detect lingering Olmec influence in the serpentine forms of the surrounding crest. What is purely Zapotec, however, is the explosive, radial composition and the piece's insistent two-dimensionality, in spite of the rather deep modeling.

Who or what is depicted here? The elaborate tombs, both Zapotec and later Mixtec, at Monte Albán strongly suggest the sort of ancestor worship found at various Maya sites, and the figure guarding Tomb 104, which still has the body and base, certainly shows a human figure dressed in ceremonial finery referring to the gods. We might therefore conclude that the images are dynastic portraits, but the possibility that they honor mythic heroes (compare Quetzalcóatl), guardian figures (compare ancient Chinese art), and shamanistic alter egos cannot be ruled out.

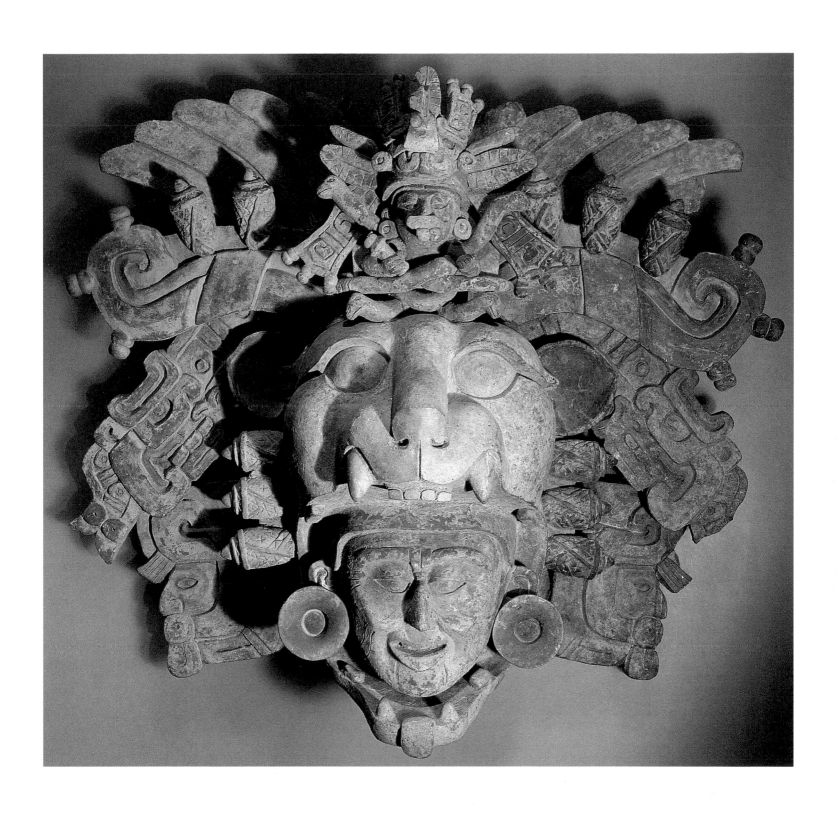

Shield Jaguar and Lady Xoc

c. 724–750

Maya

Lintels 24 and 26 from Structure 23, Yaxchilán, Chiapas, Mexico.
Sculpted limestone. Each approximately 43 ³/₁₆ x 30 ¹¹/₁₆ inches (109.7 x 77.9 cm).
Museo Nacional de Antropología, Mexico City and The British Museum, London.

Yaxchilán lies within an oxbow bend of the Usumacinta River in the Mexican state of Chiapas, close to the Guatemalan border. The site is almost halfway between Palenque at the far western border of Maya culture and Tikal in the Petén region of Guatemala. The culture that reached its peak at Yaxchilán in the seventh and eighth centuries (c. 580–800) thus reflected a wide variety of influences from other Maya centers, although the closest artistic ties were with Palenque. Yaxchilán was ruled in the mid-700s by two kings, now called Shield Jaguar and Bird Jaguar, who were probably father and son and whose military and ritual exploits were celebrated in highly detailed reliefs.

The images shown here formed part of a series of decorated lintels (architectural elements) depicting Shield Jaguar and his queen, Lady Xoc. In the image at the left (lintel 24), Shield Jaguar stands guard as Lady Xoc performs a blood-letting ceremony, drawing a spiked cord through her tongue, which she has pierced with the stingray spine shown in a basket at her feet, next to the folds of her exquisite gown. On the intervening panel (lintel 25, not illustrated here) Lady Xoc's self-sacrifice produces a vision of a warrior, presumably Shield Jaguar himself, emerging from the mouth of a celestial serpent. This having augured well, Lady Xoc, her face streaked with blood, then presents armor and weapons to Shield Jaguar on lintel 26, which includes the knife in his hand, a padded tunic, and the jaguar helmet that she

holds. The jaguar recalls small effigies of the Jaguar God of the Underworld that Maya kings are shown holding in reliefs at other locations, such as Tikal. The inscription on the Yaxchilán panel declares, with a precision typical of the sophisticated Mesoamerican calendar, that Lady Xoc presented the armor to Shield Jaguar on what we call February 12, 724.

Lintel 26 not only offers a glimpse of the ritual life of the elite in a vanished society but also suggests strong parallels with human culture worldwide. We may recall Medea working magic for Jason, or Venus bringing magic armor to her mortal son, Aeneus, in the Roman poet Virgil's *Aeneid*. Virgil used his tale of Aeneus to provide a mythical underpinning for the Julian dynasty under the emperor Augustus, a theme also found on the sculpted monument called the *Ara Pacis Augustae*, where Augustus and his family, including his wife and other women, are shown moving in procession to (an animal) sacrifice in fulfillment of religious duties. The sculptors of the Yaxchilán workshop express something extremely similar, in spite of the rather different sacrificial rite! A mixture of the mystical and mythical (as in Virgil) is combined with a sense of public ritual (as in the *Ara Pacis*) in an attempt to bolster what might be called the divine right of Shield Jaguar to rule. As in the Roman examples, the justification only made sense in the wake of military victory, a theme also well represented at Yaxchilán.

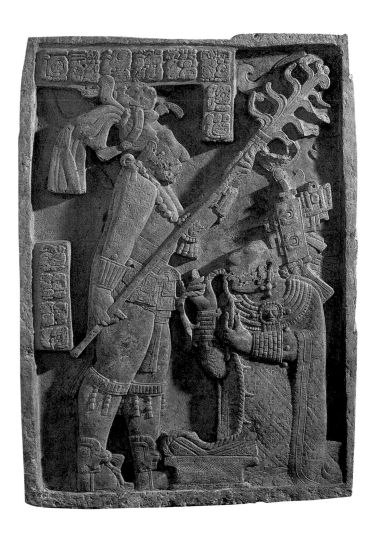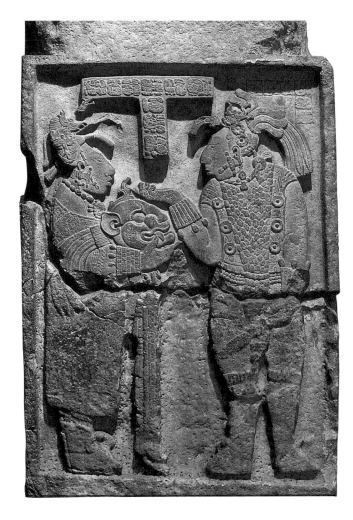

Flanged Cylinder with the Jaguar God of the Underworld

c. 600s

Maya

From the Temple of the Foliated Cross, Palenque, Tabasco.

Painted ceramic. Height: 28 inches (71.1 cm).

Museo Regional de Antropología, Villahermosa, Tabasco, Mexico.

Mirrors held a special fascination for ancient Mesoamericans. Obsidian (volcanic glass) mirrors, both the curved and the harder-to-make flat types, were important as jewelry and perhaps as badges of rank from Olmec times. Apart from their seemingly magical ability to reflect reality, mirrors were also important tools, since concave and parabolic types could be used to focus the sun's rays for singeing or even producing flames. The image of a smoking mirror refers to this burning function. Because of their reflective and catalytic properties, mirrors are typically associated with the sun in many world cultures.

Palenque guards the western limits of Late Classic Maya expansion. Its back to the rising Chiapas plateau, Palenque looks out over a vast plain, stretching north to the Usumacinta river valley and the Gulf Coast. From about 600 to 750, under a dynasty reinvigorated by the ruler Pacal II (the name also means "shield" in Maya), the city of Palenque expanded tremendously, with local architects achieving important innovations in both structure and design. One architectural innovation was to use much lighter decorative elements at the tops of buildings, allowing more vaulted areas inside. This cylinder—much lighter than a similarly shaped stone object—was one of a group of like ceramic solar images found at Palenque embedded in the stepped sides of the so-called Temple of the Foliated Cross, part of a complex of three temples related to both solar worship and healing patronized in the late 600s by Pacal's son and successor, Kan Balam. The cylinder, along with its fellows, probably served as a type of finial decoration proclaiming the sun god while providing color and animated form to the otherwise classically simple lines of the Palenque buildings.

The mirror-smooth eyes (perhaps originally silvered or painted white) that figure so prominently on the principal face depicted in this ceramic sculpture, along with the celestial crosses and other symbols on the flanges of the cylinder, do suggest an association with the sun. However, the feline lips and cruller-like protrusion over the nose indicate that it is not the daylight sun but rather the "night sun" to which the statue refers. Historians such as Mary Miller and Karl Taube have suggested that the face may be identified as the Jaguar God of the Underworld, part of the enormously complex Maya system of a nine-level underworld and the associated afterlife. The Jaguar God is therefore a "sun" in an inverted, symbolic sense, held in opposition to our physical existence in the light of day. This god also finds precedents, like so many aspects of Classic civilization, in Olmec forms: in this case, the were-jaguars found in Olmec burial groups.

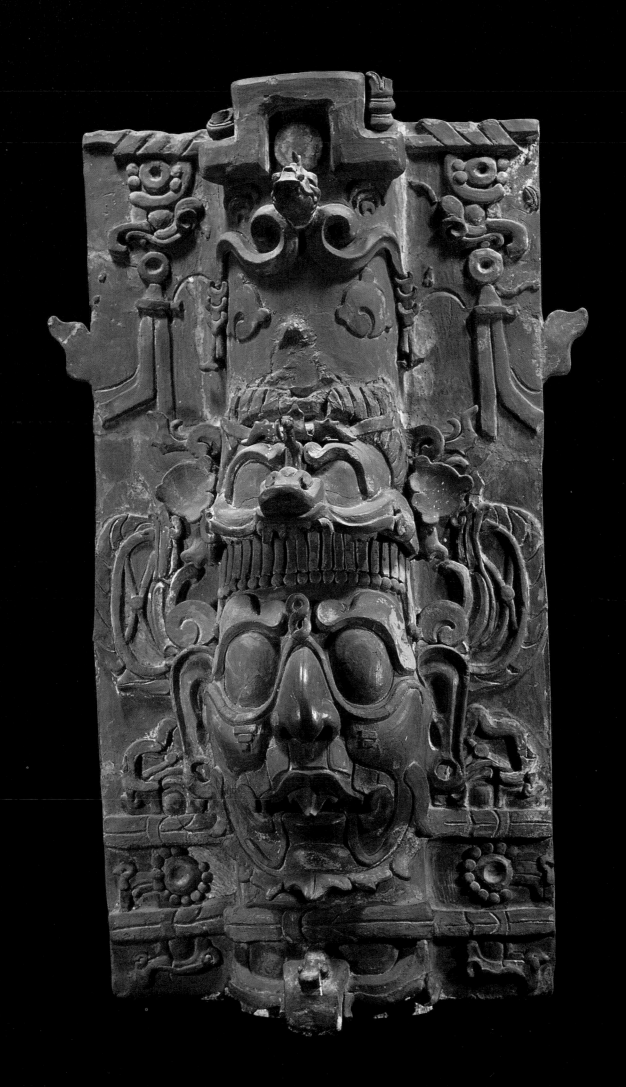

Head

c. 650–700

Maya

From the Temple of the Inscriptions, Palenque, Tabasco.
Stucco. Height: 17 inches (43.1 cm).
Museo Nacional de Antropología, Mexico City.

P alenque epitomizes Late Classic Maya cul-
ture. Its stately buildings are at once
dignified and innovative, with the sort of
urban engineering, such as an aqueduct,
more often associated with the ancient Romans. One
of the principal buildings, the so-called Palace, was
a secular structure with plumbing, but may not have
been a residence. (Large-scale houses—presumably
the actual residential palaces of Palenque's rulers—
have also been found at the site.)

In addition to the Palace, Palenque features a promi-
nent complex of three religious buildings and a sepa-
rate structure called the Temple of the Inscriptions.
As is often the case at Mesoamerican sites, the pyra-
mid that held the actual temple building covered a
tomb, understood as a gateway to the underworld.
(An interior staircase originally connected the temple
rooms to the tomb.) Inside the tomb, covered with
jade and painted red with the pigment cinnabar, lay
the body of dynastic ruler Pacal II (Shield II). Even
the exterior of the temple pyramid proclaims the

funerary motif as it rises in nine tiers, symbolic of the
nine circles of the underworld, while thirteen corbels
inside proclaim the thirteen levels of the cosmos.
Pacal's sarcophagus shows the ruler in ecstasy, about
to be swallowed by the jaws of death while a fantastic,
bird-crowned tree springs from his abdomen. (The
image is remarkably similar to medieval European
images of the Tree of Jesse or noble family trees.)

The head illustrated here is one of two found under
the sarcophagus, perhaps removed from the roof
comb (architectural decoration) of the exterior. Since
the sarcophagus also honors Pacal's ancestors, it is
tempting to speculate that this head is also some sort
of dynastic portrait—certainly the elaborate head-
dress suggests royal or noble lineage. The remarkably
classic features, animated by the detail of the open
mouth, as though the figure were lost in thought,
breathing, speaking, or singing softly, produce an
effect at once lyrical and striking. Whoever it may
represent, it is one of the great masterpieces of
ancient art.

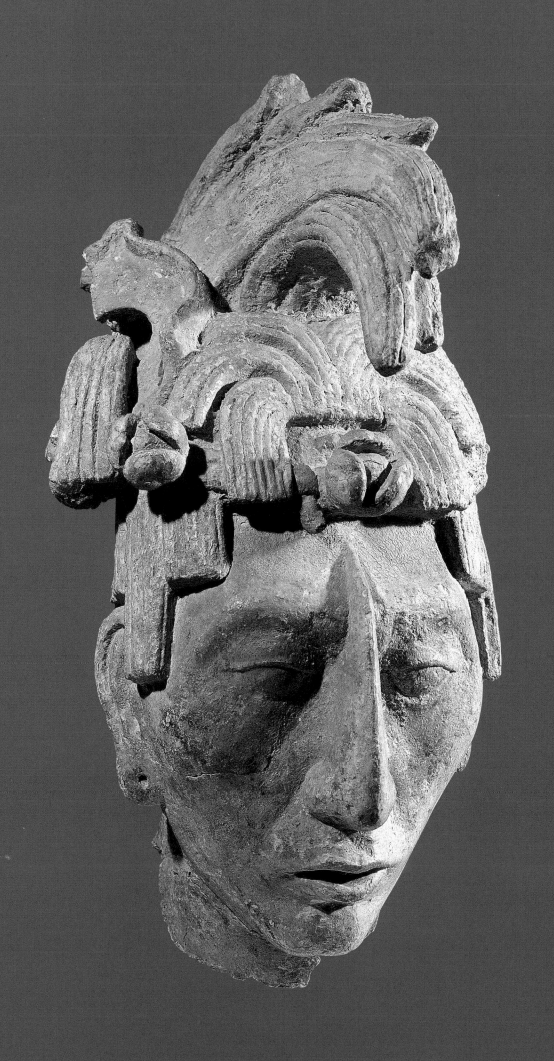

Mixtec Shield Brooch
Postclassic Period

From Yanhuitlán, Oaxaca.
Gold and turquoise. Height: 4 ¾ inches (12 cm).
Museo Nacional de Antropología, Mexico City.

From the earliest times, jewelry played a central role in the material culture of Mesoamerica. Olmec images show rulers adorned with mirrors, pectorals (ornaments hanging on the chest), other pendants, and earflares, often made of highly treasured jade. Jewelry from the Olmecs, Teotihuacán, and earlier Maya was avidly collected by later peoples, and a mirror or ancient jade piece often became the centerpiece of a new ensemble.

Unfortunately, jewelry is at once precious, easily portable, and fragile. Even before the gold-hungry conquistadores arrived, older jewelry was broken up for its jade, the gold melted down, the artifice reworked, lost, stolen from graves, or captured as booty. Few objects have survived the colonial era and the even more systematic looting of the nineteenth and twentieth centuries.

An important exception is the Mixtec jewelry that has been found in tombs at Monte Albán and other sites in Oaxaca. Indeed, Mixtec sculpture, wall murals, and illustrated manuscripts (codices) provide some of our most important windows into the Postclassic world. Ancient Oaxacan art, whether Mixtec or Zapotec, is often characterized by an exquisite classi-cism. This is true on a small scale, as here, or on an urban scale, as in the remarkable buildings at Monte Albán or at Mitla, another Zapotec center.

The Mixtecs were renowned for their metallurgical skills. Their works were particularly admired by the Aztecs, who allowed a colony of Mixtec artisans and, presumably, traders to reside at Mexico Tenochtitlán. Indeed, trade in precious stones was as old as the Olmecs, who valued jade, as did all subsequent Mesoamerican cultures. Furthermore, the trade routes were quite extensive. Recent analysis of trace elements in turquoise suggests that stones mined in Arizona were used in central Mexico, and may have been traded as far south as the Inca lands in Peru.

The brooch shown here probably reflects the Miztec's interchange with Aztec culture. Indigenous illustrated manuscripts of the early colonial period, such as the *Codex Ixtlilxochitl* (Bibliotheque Nationale, Paris), depict similar shields. Perhaps the brooch was a badge of a military order, analogous to the Knights of Santiago in Spain or the Order of the Garter in England. Whatever its original function, it is a stunning creation, inspiring innumerable modern imitations. Like all classic art, it has a beauty that is timeless.

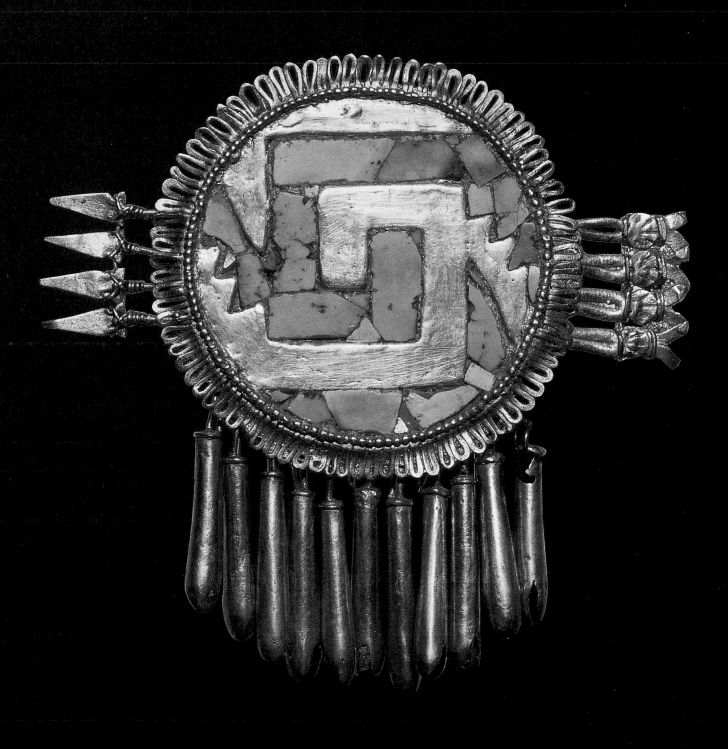

Piedra del Sol (Aztec "Calendar")

c. 1470–1521
Aztec, Imperial Era

From the sacred precinct of Mexico Tenochtitlán.
Painted limestone.
Museo Nacional de Antropología, Mexico City.

This enormous object, which has come to symbolize ancient Mexico to millions of modern viewers, summarizes the Aztec worldview. It is one of a handful of monumental cult objects preserved from the most important temples of imperial Mexico Tenochtitlán (ancient Mexico City). The explosive design and exotic imagery have made it one of the most reproduced works of art: even Tiffany's once replicated it as a silver platter (Brooklyn Museum, New York).

Not so much a calendar as a diagram of apocalypse, the stone represents a solar disk (marked by triangular spikes), inscribed with the twenty basic day names and surrounded as if carried in the sky by two fire serpents. (The day names are clearly visible and include such easily recognizable symbols as ocelot, deer, rabbit, etc.) Inside the ring of day names, at the center of the composition, a hideous face extends a blood-thirsty tongue from a toothy grimace. Around the face, four calendar dates (day names plus sequence numbers) appear in rectangles, while a series of domino-like representations of the number five form a belt around the outer rim of the day names. It is from this band of fives that the rays of the sun emerge.

The overall image is therefore that of the Fifth Sun, or fifth cosmic era, with the dates in rectangles being the days on which the previous eras ended. The "frames" of the date rectangles are joined in a continuous strapwork outline; the resulting inscribed shape is that of the day name *ollin*, or Movement, the same sign found at about two o'clock on the circle of day names. The four dot shapes embedded at the sides of the central area signify that the present era will end on the date Four Movement. (A fifth dot appears at the very bottom, from which it might be argued that the doomsday was meant to be Five Movement, although the dots also might have been meant to represent both Four Movement and the Fifth Sun.) Assuming that the central face really is an earth monster (although other hypotheses have been advanced), the resultant idea is that on a specified Four Movement, the sun would collapse into the earth, destroying everything. In modern terms, the end of the Earth is here prophesied to occur on a Tuesday, November 12th.

In fact, the era of the Fifth Sun was even more fragile, since the Aztecs believed that in order to continue to be vigorous, the sun needed to be "fed" with the blood of sacrificial victims. Hence the horrific pace of human sacrifice, in which a constant stream of captives, prisoners of war, and persons sent as tribute from client states were butchered in a desperate attempt to keep the cosmic system functioning.

This obsession proved to be the Aztecs' undoing. Powerful tributaries, such as the separate Tlaxcala Indians, seized upon the Spanish intrusion as an opportunity to win independence. It was the Spaniards' Indian allies whose numbers ensured the triumph of the technologically superior conquistadores. In the end, however, the horrors of viral and bacterial diseases brought by the Europeans proved an even greater scourge than the blood lust of Aztec ritual, although the hecatomb would be spread out over the first century of colonizations, in a series of epidemics.

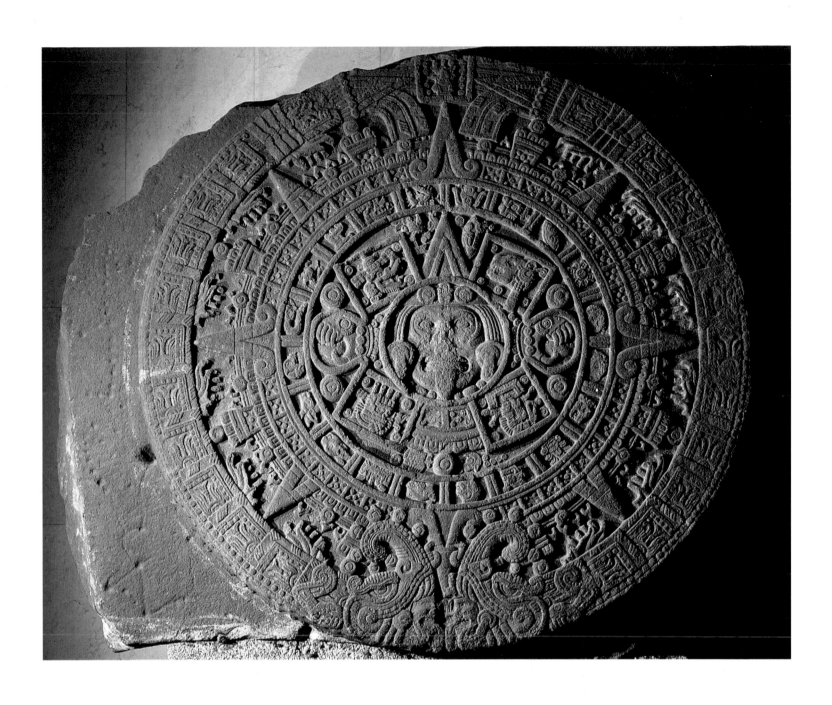

Coatlícue

c. 1470–1521
Aztec, Imperial Era

From the sacred precinct of Mexico Tenochtitlán.
Painted limestone. Height: 8 feet, 5 inches (256.5 cm).
Museo Nacional de Antropología, Mexico City.

Mexico is a country obsessed with death. From the nine underworlds of the various Prehispanic civilizations, through the martyrs and *Cristos yacentes* (recumbent Christ figures) of the colonial churches, to today's candy skulls and yellow chrysanthemums of the Día de los muertos (the Mexican Halloween), death and the afterlife are a constant theme.

This immense sculpture depicts Coatlícue, the mother of the Aztec gods and, indeed, of human beings, in her guise of devouring monster and symbol of death. (An earth monster is also sculpted on the underside of the base.) Presented as though with her head severed and replaced by two rattlesnakes (probably symbolizing two streams of blood), Coatlícue is also girdled with snakes and adorned with a necklace of human hands, hearts, and a skull. The resulting image is so terrifying that the sculpture is said to have been reburied after its rediscovery near the Mexico City Cathedral in 1790.

According to Aztec legend, Coatlícue became pregnant with Huitzilopochtli, the Aztec's principal deity, who is associated with the sun. Coatlícue's other children, led by her daughter, Coyolxauhqui (associated with the moon), rebelled, and in the attack, Coatlícue was beheaded. Huitzilopochtli then arose, fully mature and armed, from his mother's body, defeated his siblings, and dismembered Coyolxauhqui

on the base of Coatlícue's shrine at Coatepec (the "hill of snakes") near Tula. A round stone relief of the dismembered Coyolxauhqui was apparently placed at the foot of the main temple pyramid at Tenochtitlán, which was crowned by twin pavilions dedicated to Tlaloc (the rain god) and Huitzilopochtli. Whether the Coatlícue was also located there (the base of the temple included a frieze of snakes and Coatlícue's necklace alludes to human sacrifice) or in another temple, perhaps the so-called "Black House" dedicated to her, remains unclear.

Although the statue refers to her legend, it certainly is not a depiction of how Coatlícue might have looked, except in some kind of nightmarish metamorphosis. In contrast to the Olmec were-Jaguar or the Maya rain god Chac, Central Mexican deities were seldom portrayed in their anthropomorphic forms. Rather, their images are symbolic or emblematic of a concept, such as a force of nature or a particular spiritual power.

No aspect of the natural world is more feared than death, especially given the general Prehispanic focus on the underworld and the Aztec's special compulsion to keep the Apocalypse at bay through blood sacrifice. The Coatlícue's horrific form is therefore entirely appropriate; she remains as terrifying and repulsive today as she must have been when she was the last thing seen by Aztec sacrificial victims.

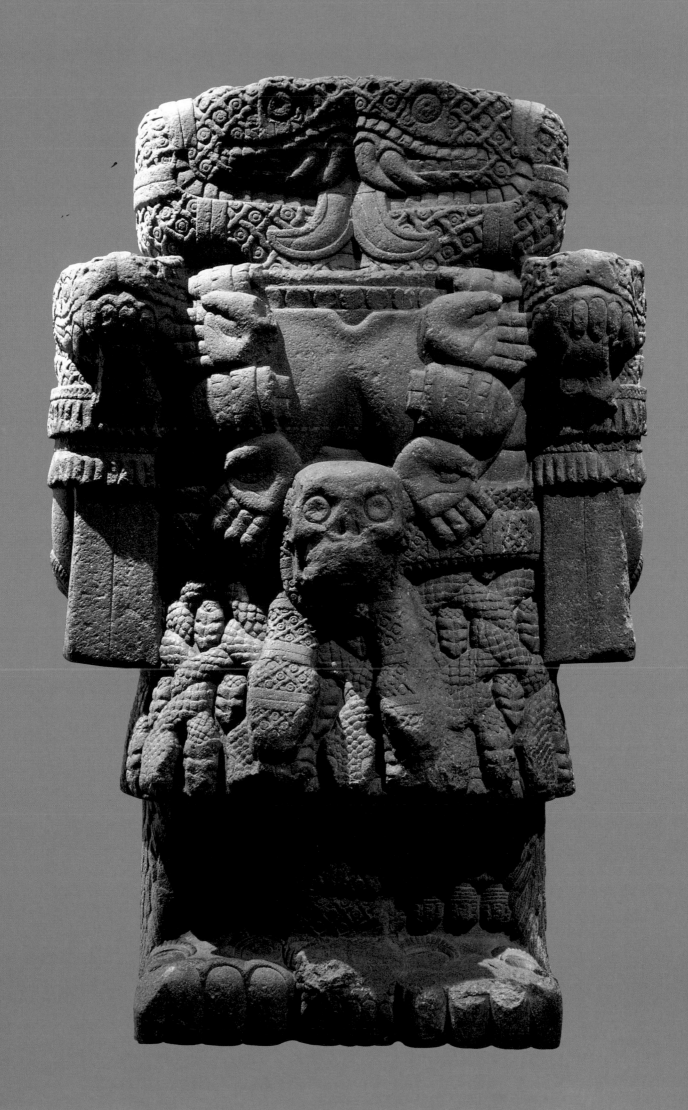

Quetzalcóatl
1325–1521
Aztec

Carved stone. 17 ³⁄₈ x 9 ⁷⁄₈ inches (44.1 x 25 cm).
Collection Musée de l'Homme, Paris.

Among the many legends of Mesoamerican civilization, those surrounding Quetzalcóatl are particularly fascinating. There were in fact two Quetzalcóatls: a semi-legendary Toltec ruler, Lord Quetzalcóatl of Tollán (presumably the same as modern Tula in Hidalgo), and an important god, Ehecatl Quetzalcóatl, the feathered serpent who breathes the wind (Ehecatl). (The feathers that covered the *coatl* snake were understood to be the brilliant plumage of the quetzal bird.) Ehecatl Quetzalcóatl was associated with fertility and the creative union of the sky (feathers of the bird) and the earth (the serpent). Among the Toltec-Maya of northern Yucatán, the name was translated as Kukulcan.

Lord Quetzalcóatl of Tollán lived sometime between 950 and 1000. He may have elevated his namesake to the center of Toltec worship, and may have been persecuted for doing so—legend has it that he traveled east, towards the Gulf Coast, before he disappeared. He was said to be transformed into the planet now called Venus, one of the brightest objects in the sky. Whether it was he or some other leader of a similar name who led the Toltec invasion of northern Yucatán around 986 is not known.

The Aztecs who owed much to the Toltecs, revered both the god and the man Quetzalcóatl, and the rulers of the Aztec Empire at Mexico Tenochtitlán traced their dynasty back to him. This was not mere genealogy. Like many ancient peoples, the Aztecs found themselves imposing an empire on cultures that were older and often superior to the Aztecs' own. The appeal to Teotihuacán and to the Toltecs brought legitimacy, both political and religious, to Aztec rule.

Any image of Quetzalcóatl is complex, an amalgam of glyph (pictographic writing), theology, and history. The use of glyphs made a type of verbal visual pun possible, in which the depicted image said its own name: feathered serpent. Sculpted feathered serpents are extremely common in Aztec art, but here, other imagery intervenes, such as depictions of eagle or jaguar knights in their ceremonial costumes, priests dressed in intact human skins as Xipe-Totec, the flayed one, and two-dimensional representations of the god Ehecatl Quetzalcóatl. The feathered-serpent skin is worn like a cloak, while the forms on the earrings and necklace recall the fangs and forked tongue of the serpent. The figure is also exhaling, a probable reference to the wind or divine breath of the god.

Does this mean that the figure represents the god rather than the historical Quetzalcóatl? By 1500, the two had become so intertwined that it was impossible to separate their histories or imagery. Any reference to the Toltec leader thus became a reference to the god, and, at least for the Aztecs, any reference to the god implied an awareness of the historical figure. Some of this ambiguity finds expression in the tensions between the blocklike, abstracted general form of the piece and the lifelike energy of the face and feathers. Indeed, Aztec art in general may be described as a balance of static form with dynamic modeling; of hieratic images with humanistic naturalism; of a stiff, self-conscious classicism with the wild energies of color and vibrant detail; of deathlike forms with those that celebrate life.

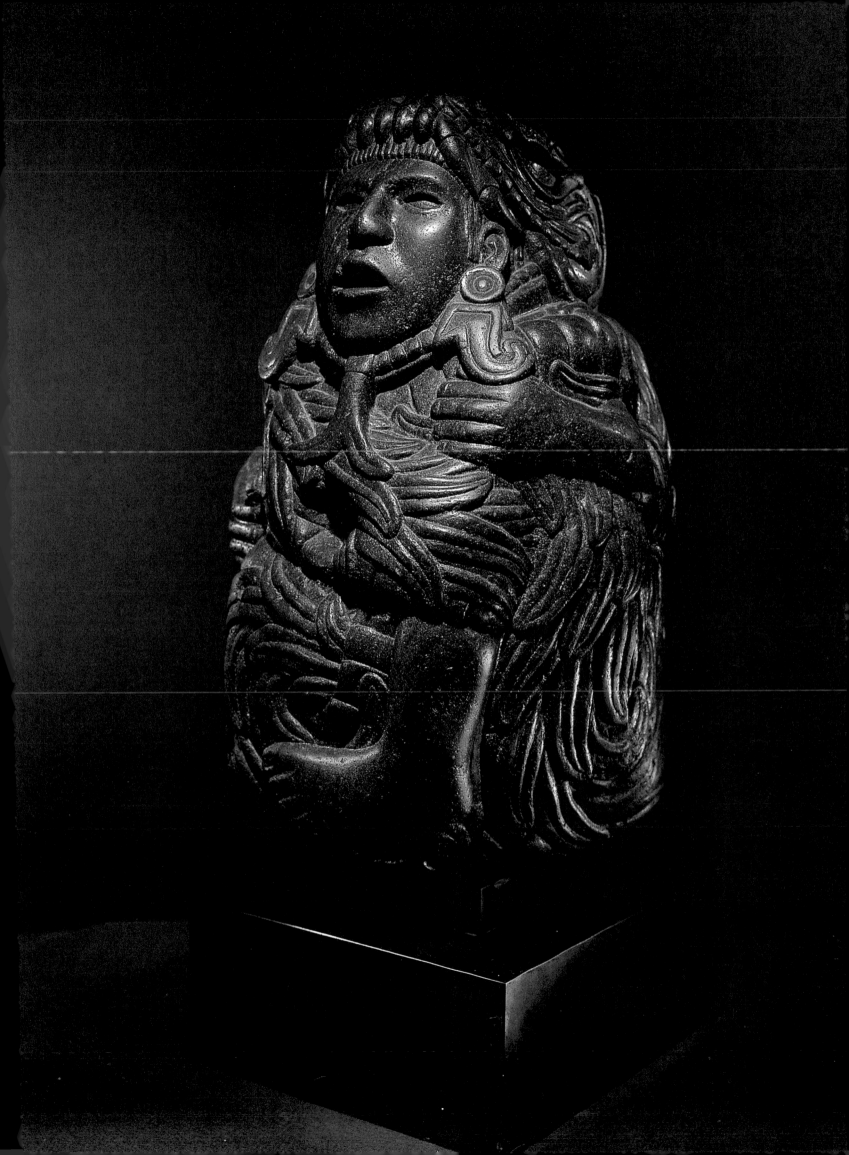

Feather Headdress

c. 1519

Aztec

Quetzal and cotinga feathers, gold, and beads. Height: 49 inches (124.5 cm), irregular.
Museum für Völkerkunde, Vienna.

Also I saw the things which were brought to the King from the New Golden Land: a sun entirely of gold . . . a moon, entirely of silver . . . sundry curiosities from the weapons, armor, and missiles; very odd clothing, bedding, and all sorts of strange articles for human use, all of which is fairer to see than marvels. . . . I have never seen in all my days that which so rejoiced my heart as these things. For I saw among them amazing artistic objects, and I marveled over the subtle ingenuity of men in these distant lands. (Albrecht Dürer, translation from Mary Ellen Miller, *The Art of Mesoamerica*, London,1996, p. 202)

In the fall of 1519, as Hernán Cortés and his men neared the Aztec capital of Mexico Tenochtitlán, Moctezuma II sent gifts, including costumes. Subsequently, these and other objects were sent to the Emperor Charles V in Brussels, where the German Renaissance artist Albrecht Dürer saw them and made the response quoted above.

Although Dürer did not specify featherwork in his list of "marvels," many of the objects he saw must have been made in this quintessential Prehispanic technique. Using the iridescent feathers of quetzals (green), cotingas (blue), and hummingbirds, particularly those found in the region of Michoacán, ancient Mexican artisans fashioned textiles out of whole feathers and mosaic pictures out of cut fragments. Feathers were a popular medium that survived into colonial times and were even revived in the nineteenth century.

Might this be Moctezuma's crown? Certainly, the Aztec emperor would have worn some similarly splendid headdress, and it would have been an appropriate gift to someone such as Cortés, who was thought to be a reincarnation of Quetzalcóatl. Although there is no documentation, circumstances strongly suggest that Cortés sent Moctezuma's gift to Charles V, a Belgian leader of the Hapsburg family, who was both king of Spain and Holy Roman emperor. He in turn gave or lent the headdress to his Austrian cousins, who incorporated it into what would become the Imperial collections at Vienna, which later became the capital of the empire and the principal seat of the Hapsburg family.

The headdress is extraordinary, even apart from the sheer luxury and stunning color combinations, made even more striking by the iridescence and delicacy of the feather medium. The radial energy of the composition, like a thousand rockets emanating from a central source, is carefully channeled in a vertical direction, emphasized by the central tuft. The effect increases not only the wearer's height but also his or her command of surrounding space. Here, perhaps more so than in any other object, the theatricality of the Aztec imperial regime finds perfect expression.

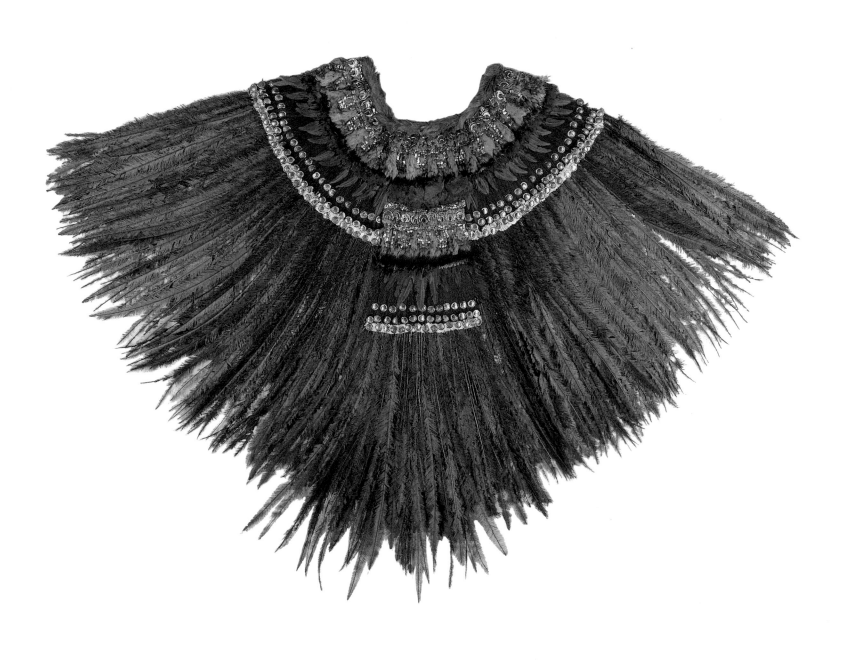

Tlaloc
c. 1570–1670

Codex Ixtlilxochitl (Fol. 110 verso)
Mixed media on European paper. 12 ¼ x 8 ¼ inches (31 x 21 cm).
Bibliothèque Nationale, Paris.

From the 1520s until the first decades of the seventeenth century, a new, hybrid style of art arose in Mexico, blending indigenous Prehispanic styles and techniques with images and artistic values brought from Europe. This Indochristian style was cultivated in the many mission areas of the new viceroyalty, where local tribal leaders dominated patronage and where the utopian hopes of the Franciscans, Augustinians, and other orders sought expression in a new society.

Very few Prehispanic illuminated manuscripts have survived, but those that do demonstrate an incredible richness of expression. At the time of initial Christian contact, priests and political leaders sought to destroy Prehispanic books they felt were tools of the old idolatries. Subsequently, however, the missionaries came to realize that they had to understand the old culture in order to communicate the new faith. This, together with the Renaissance thirst for science and history, not to mention the need to specify legal ownership of land and feudal rights, led to the commissioning of new scrolls, codices (plural for "codex," a manuscript bound like a book), and fan-fold manuscripts.

The *Codex Ixtlilxochitl* is such a book. Named for Fernando de Alva Ixtlilxochitl (1558–1648), a historian descended from the lords of Texcoco, it may have been compiled by him or by a successor historian in Mexico, Carlos Sigüenza y Góngora (1645–1700), out of earlier elements.

The image of *Tlaloc* (the rain god) is a wonderful mixture of the European and the Prehispanic. It appears in a section of the codex that copies information from an encyclopedia of Aztec ritual of around 1529–1553, and shows the Aztec rain god with human legs and arms drawn in the European style, using chiaroscuro (variations of light and dark) and perspective. The head and tunic are purely Aztec in style, however—flat, two-dimensional, but colorful. The effect is of a priest dressed up as Tlaloc, a usage with some precedent in Prehispanic representations, but here probably the result of the combination of styles.

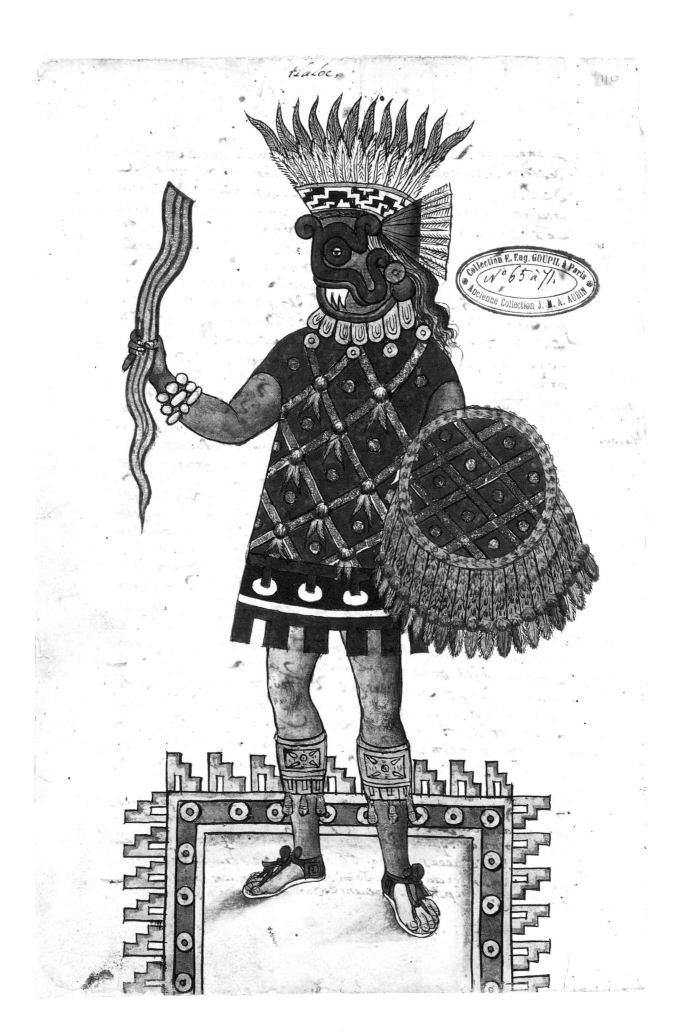

The Mass of Saint Gregory the Great

1539

Workshop of San José de los Naturales, Mexico City

Feather mosaic on wood, with mixed media. 26 ¼ x 22 inches (66.7 x 55.9 cm).
Musée des Jacobins, Auch, France.

In 1537, Pope Paul III intervened in a European dispute about the human nature of indigenous Americans by issuing a papal bull declaring them capable of reason and deserving of the sacraments, as administered in the new American missions. Today, the naive and culturally self-centered nature of this pronouncement seems offensive, but it had enormous repercussions at the time, preventing, for example, the sort of wanton displacement of populations and even genocide that characterized English colonization in North America. (Working-class Indians were still badly exploited in the Spanish colonies, but the bull gave the Franciscans and other orders theological ammunition with which to defend their spiritual charges.)

Featherwork was one of the most important art forms in Prehispanic Mexico, and continued to be so after the Spanish conquest. At centers such as the school of San José de los Naturales in Mexico City, founded by the Flemish Franciscan Friar Peter of Ghent (a relative of the emperor, Charles V), workshops dedicated to feather mosaics were set up in order to produce new Christian images using the old technique. The art form is certainly among the most exotic ever created: iridescent feathers of hummingbirds and other tropical species are fixed onto panels with natural glues, including the poisonous sap of certain orchids. Amazingly fine details can be "painted" with the feather mosaic technique, creating a startling effect.

The present example represents a miraculous mass celebrated by Pope Saint Gregory the Great (sixth century), in which a vision of Christ allayed the doubts of one of Gregory's companions. According to its inscription, the object was commissioned, and possibly made, by Diego de Alvarado Huanitzin, indigenous governor of Mexico City starting in 1538, who had also been governor of Mexico Tenochtitlán before the Conquest. The work was made as a gift for Pope Paul III in 1539 at San José de los Naturales "under the supervision of Friar Peter of Ghent"—presumably in appreciation of the papal bull of 1537. Whether the pope ever saw it is unknown. The mosaic, in remarkable condition, came to light in 1987 and is now in a French museum—some think it was captured by French pirates on the way to its intended destination.

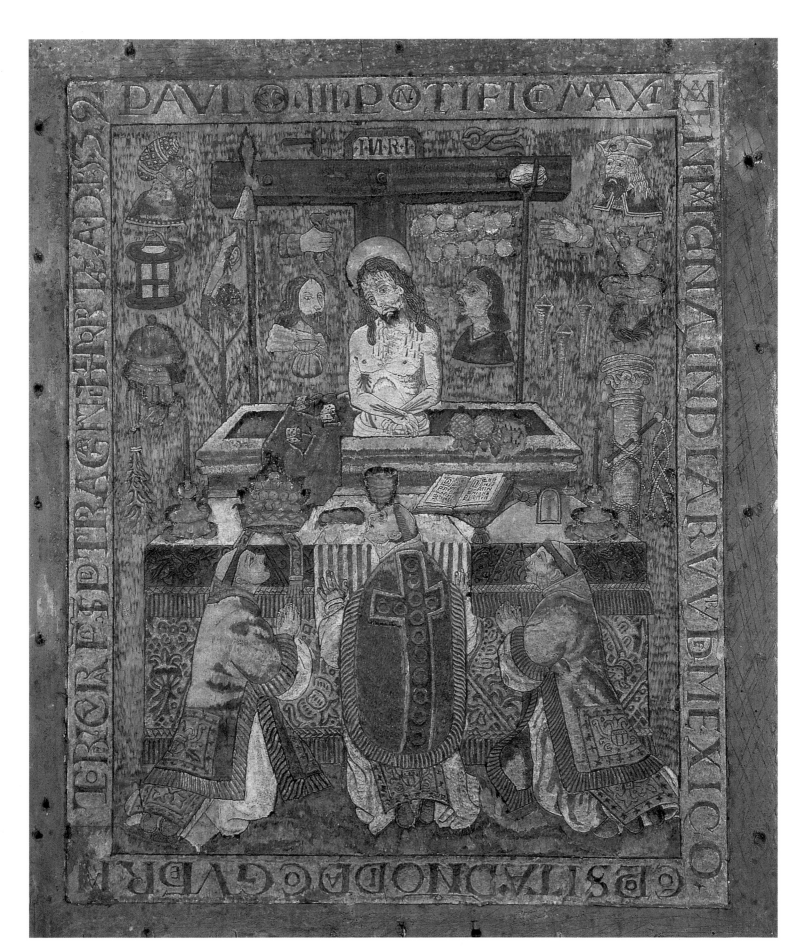

Saint Francis in La Portiuncula
c. 1609
Baltasar de Echave Orio (c. 1558–c. 1620)

From the Franciscan church at Tlatelolco

Oil on canvas.

Pinacoteca Virreinal de San Diego, Mexico City.

The *Saint Francis in La Portiuncula* is not only a strikingly beautiful work imbued with spiritual value, but also a reminder of how profoundly Mexican culture has been influenced by the Roman Catholic Church and the important role that Basques have played in the New World.

Because the conquest, colonization, and missionization of Latin America occurred before and during the Roman Catholic Counter-Reformation (1550–1650), the values of the Counter-Reformation church were those implanted in the cultural soil of the New World. Take, for example, the role of the various monastic orders of the church. During the period of the Counter-Reformation, the Roman church, as part of its reform, seized upon monastic saints as models for the spirituality it sought in all believers. Nowhere is this more apparent than in images of Saint Francis.

Francis of Assisi (c. 1181–1226), founder of the Order of Friars Minor, or Franciscans, is by far one of the most popular Roman Catholic saints, and nowhere more so than in Mexico, which was first missionized by the Franciscans. Preaching a simple doctrine emphasizing piety, emotional involvement, and brotherly love, Francis had a tremendous influence in his lifetime, which only increased after he was canonized in 1228. Early in his ministry, Saint Francis rebuilt the chapel of Saint Mary of the Portiuncula at Assisi, which became the church for the mother house of the Franciscan order. It was in this church that he died in 1226.

Images of Francis praying devoutly in the Portiuncula, with Christ and the Virgin Mary in a vision above, were not included in early depictions of Francis's life. During the Counter-Reformation, however, with the Church reemphasizing devout prayer as a means of spiritual blessings, the vision at the Portiuncula joined the stigmatization of Saint Francis at the center of Franciscan imagery. Faithful viewers, and especially the Franciscan brothers at Tlatelolco who commissioned the picture, could hope that, like Saint Francis himself, their prayers would be answered by direct contact with Christ or the Virgin.

As an intellectual, author of a book on the antiquity of the Basque language, and founder of the principal dynasty of colonial painters, Baltasar de Echave Orio dominated Mexican painting from 1600 to 1620. He was born in the Basque country of Spain around 1558 and brought his region's history and vision with him to Mexico in 1580. His date of death is unknown but is thought to have been around 1620. Echave Orio, along with his contemporaries Simon Pereyns and Andrés de la Concha, would be considered the founders of the European-based Mexican colonial tradition. Works such as these demonstrate the high quality found in Mexican painting at the outset of the seventeenth century. Echave Orio would continue to influence Mexican painting for a century and a half, nearly to the end of the colonial era.

The Marriage of the Virgin *(Los Desposorios de la Virgen)*
c. 1620–1635
Luis Juárez (c. 1585–after 1636)

Signed lower center [fragmentary]: "Ludovicus"

Oil on linen. 83 x 57 inches (210.8 x 144.8 cm).

Collection of Davenport Museum of Art, Davenport, Iowa. Gift of an Anonymous Donor.

Luis Juárez was probably born in Mexico around 1585. His active period was between 1610 and 1630. As the father of José Juárez and a follower, and possibly a pupil, of Echave Orio, Luis Juárez represents the point at which the central dynasty of Mexican colonial painters comes together. With his contemporaries, Baltasar de Echave Ibía (Echave Orio's son) and Fray Alonso López de Herrera, Luis Juárez represents the Counter-Reformation style at its most typical, before the arrival in Mexico of the new Baroque forms. Luis Juárez's descendants, Nicolás and Juan Rodriguez Juárez, carried the family atelier into the eighteenth century.

According to the Apocryphal Lives of the Virgin, Mary was brought to be raised in the temple at Jerusalem. When she reached marriageable age, the temple priests sought to choose a husband by asking suitors to bring rods to the altar. Saint Joseph's rod burst into flower and was visited by a heavenly dove, both seen in the picture. Mary and Joseph were married by the High Priest, who is here clothed in a double-crescent mitre, a priestly robe, an apron-like garment called an *ephod* fringed with bells, and a gold breastplate with twelve stones for the twelve tribes of Israel, derived from the biblical description in Exodus 28. The myriad eyes on the hem symbolize the omniscience of God and resemble the eye of God in a triangle found on the United States' dollar bill.

Paintings of this type were used in a variety of contexts in colonial Mexico. They might have been stand-alone altarpieces, units in larger, multi-picture altar ensembles, or parts of a series depicting, for example, the life of the Virgin. Although we cannot be sure, the history of this work suggests that the first option is the most likely.

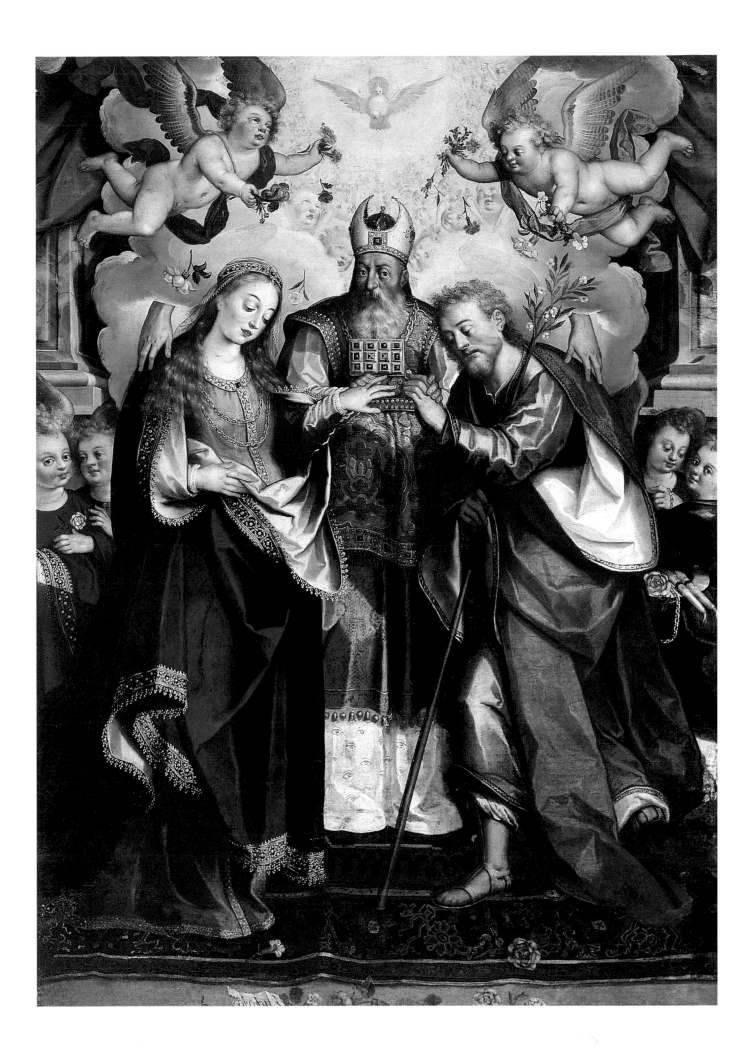

Saint Francis of Assisi Receiving the Stigmata
Signed and dated (on the other side): "fr Alº de / Herre[ra] / 1639"
Fray Alonso López de Herrera (c. 1580–after 1648)

Oil on copper (painted on both sides). 14 ½ x 11 ½ inches (36.9 x 29.2 cm).
Museum Acquisition Fund, Meadows Museum, Southern Methodist University, Dallas, Texas.

Unlike cloistered monks (and nuns) who live exclusively in monasteries, Dominicans, Franciscans, Jesuits, and certain other orders are mendicants, circulating freely in the world. Although the term *mendicant* comes from the Latin word for "beggar"—and indeed, some of the mendicant orders, including the Franciscans, once expected their "friars" to live off gifts—the broader idea was that the friars would be free to preach, evangelize, and in general, do good in society. Friars soon became common figures in folklore and literature, the most famous being perhaps Friar Tuck of the Robin Hood tales. In Italy, Spain, and Latin America, many famous artists were also friars or priests, including the author of this picture, "Fray" (Friar) Alonso López de Herrera.

López de Herrera was born in Valladolid in Spain c. 1580–1585. He went to Mexico sometime before 1609, perhaps encouraged by Archbishop Fray García Guerra, who was himself a Dominican priest. López de Herrera painted a portrait of the archbishop in 1609 and was soon enrolled in the Mexican Dominican order (also called "Order of Preachers").

Saint Francis of Assisi Receiving the Stigmata is painted on a large sheet of hammered copper, a support often used in Spanish colonial painting. What is unusual about this picture, however, is that it is painted on both sides, with the other side bearing an image of St. Thomas Aquinas. The Aquinas side is more heavily damaged than the Francis side, which suggests that the copper plate was once set as some sort of door for a tabernacle that held the communion wafers or a reliquary cabinet.

Saint Francis of Assisi was one of the most popular saints in Mexico and throughout the world. Saint Thomas of Aquinas (c. 1225–1274; canonized in 1323) was popular, too, but his following included a much more select group of educated priests, theologians, and church leaders. Indeed, it was Thomas's summary of medieval Catholic theology that was affirmed by the Counter-Reformation. Both the Dominicans and the Franciscans sponsored a Rosary devotion, and the more recently founded Jesuits looked to both orders for inspiration. Perhaps the present example was originally painted for a Jesuit church.

Saint Francis is shown full-length, kneeling, consumed by the vision of a crucifix imposed on a six-winged angel called a seraphim, which left him marked with the five wounds of Christ's passion (called *stigmata*) on his hands, feet, and side. The image shows all the characteristics of Counter-Reformation art: direct contact with the subject, muted but still luminous colors, clear and relatively simple composition, and a strong spiritual presence. More surprising by European standards at this late date (1639) is the presence of the late Renaissance style called Mannerism, as evidenced by the pearly light, the elongated body of the saint, the sudden change from foreground to background, and the twist in the pose of Brother Leo, Francis's companion. Having been founded by reformed Mannerists such as Echave Orio, the Mexican colonial school after 1600 often revived Mannerist elements, a tendency that continues into the 1700s in both painting and architecture. This combination of stylistic elements results in a picture that achieves a remarkable beauty and exquisite sense of spiritual presence so typical of Mexico in the colonial era.

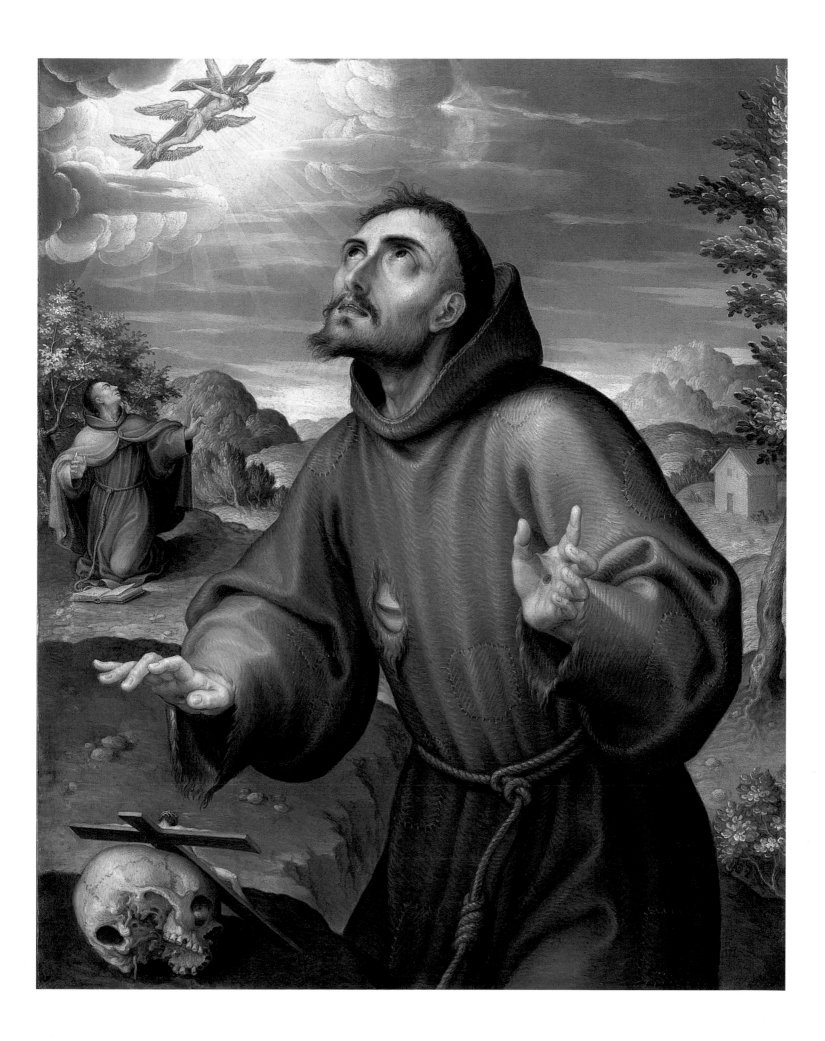

The Adoration of the Magi

Signed and dated (on cup): "Joseph Xuarez Ynbentor / año de 1655"
José Juárez (c. 1620–1667)

Oil on canvas. 81 1/2 x 65 inches (207 x 165 cm).
Pinacoteca Virreinal de San Diego, Mexico City.

Throughout Spain and much of Latin America, the gift-giving and other secular rituals associated with Christmas do not occur on December 25 (the Nativity, or birth of Christ) but rather on January 6, the Feast of the Epiphany, when the Magi, or Three Wise Men, visited the Holy Family. Indeed, Spanish boys and girls often think of the Santas in department stores as "pages" who will take their messages for Christmas presents to one of the Magi, who will in turn make sure the child's wish comes true. The Epiphany is also considered one of the great paschal feasts of the church, along with the Nativity, Easter, the Annunciation, and Pentecost.

The story of the visit of the Magi (from *Magus*, an ancient Persian astrologer-priest) is told in the Bible (Matthew 2: 1–12), with three "wise men from the East" coming to the Jewish king, Herod, seeking a child "who has been born king of the Jews, for we have seen his star in the East and have come to worship him." Traveling to Bethlehem in Judea, they encounter the Christ Child with his mother, Mary, worship Him, and offer gifts of "gold and frankincense and myrrh." By about the year 1000, the wise men had become kings, and they were subsequently dressed in turbans and exotic, Middle Eastern robes, after the expansion of Turkish power in the 1400s and 1500s. Also at this time, the Magi began to be depicted as three separate races, in order to symbolize Christianity's appeal to all the world.

José Juárez was born in Mexico around 1620, the son of the painter Luis Juárez. Some think José went to Seville in Spain at some point early in his career, so close is his style to that of the great Andalusian painter, Francisco de Zurbarán (1598–1664). José Juárez, along with the Sevillian immigrant Sebastian López de Arteaga (1610–c. 1656), who came to Mexico around 1640, brought the early Baroque style called tenebrism to Mexico. Tenebrism, also called Caravaggism after its originator, the Italian artist Michelangelo Merisi da Caravaggio (1573–1610), uses dramatic contrasts of light and dark to create a vivid illusion of reality. José Juárez passed the new style on to Baltasar de Echave Rioja (1632–1682), son of Baltasar de Echave Ibía and grandson of Baltasar de Echave Orio, and Echave Rioja in turn passed his more dynamically Baroque vision on to Cristóbal de Villalpando (c. 1645–1714), as well as to José Juárez's grandsons, Nicolás Rodríguez Juárez (1667–c. 1713) and Juan Rodríguez Juárez (1675–1728 or 1732).

José Juárez's composition follows a formula developed by Zurbarán and other Spanish masters, with added influence from the great Flemish artist, Peter Paul Rubens. (Prints after Rubens's works were readily available in Mexico.) Juárez affirms Counter-Reformation theology by representing St. Joseph as a mature but still vigorous man, in contrast to the almost senile, elderly Joseph found in medieval and early Renaissance art. As patron of the Roman Catholic Church and protector of the young Christ, not to mention a model for Christian parents, St. Joseph was an important element in Counter-Reformation piety. Like all images of the Adoration of the Magi, however, Juárez's picture focuses on Mary and the Christ Child, to whom all the nations have come to pay respect.

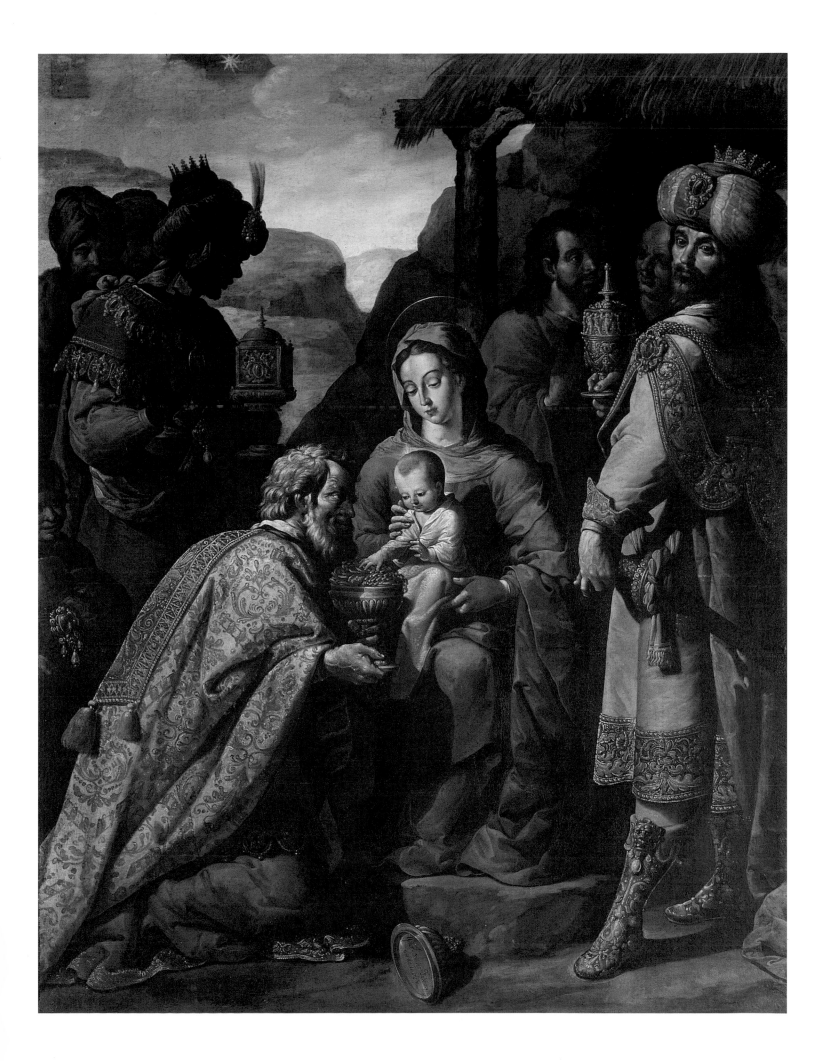

San Felipe de Jesús
c. 1630–1660

Gilded and polychromed wood. Height: 53 1/8 inches (135 cm).
Catedral Metropolitana, Chapel of San Felipe, Mexico City.

Those of us who live in modern times take for granted that the world should be divided into nation-states, but in the seventeenth century, this was a relatively new concept: a much smaller ethnic or regional unit (the so-called *patria chica*) was the norm. Spaniards, for example, were much more inclined to think of themselves as Castilian or Aragonese rather than "Spanish," at least in a political sense. Therefore, one should probably not be surprised to find how quickly Mexico developed a political identity of its own, independent of Spain. This is partially due, of course, to the high level of political development before the Conquest that encouraged self-determination, but by the 1600s, the indigenous element in society was much less powerful than it had been during the first decades of the colony. Rather, a new type of nationalism found expression in both literature and the arts as wealthy Creoles, or Mexicans of European origin, competed with Spanish royal officials for political and economic control.

Given the intense religiosity of the period, much Creole nationalism found expression in religious forms, such as devotion to the cult of the Virgin of Guadalupe at the hill of Tepeyac near Mexico City. The cult of the Franciscan martyr, San Felipe de Jesús (Felipe de las Casas, 1575–1597; called Saint Philip of Jesus in English), is similar. San Felipe and his companions were crucified as part of a persecution of Christians in Japan in 1596 and 1597. As the first Mexican-born missionary to be martyred abroad,

San Felipe quickly became a focus of national consciousness. Although, technically speaking, San Felipe was not canonized until 1862, he was treated as a saint—in effect, the first Creole saint—in Mexico from the time of his beatification in 1627.

This stunning work of art presents the saint in a combination of Renaissance and Baroque styles. Typical of late Renaissance reformed pieces is the relatively sedate pose, the gently expiring expression of the face, and the rather abstract, geometric way the symmetrical spears interact with the torso, producing an almost perfect square in the chest area. The Baroque emerges in the changes of axis from head and neck area through the upper torso to the pelvis and legs. Notice also the open pose, the hip shot out to the figure's proper left, and the one foot striding forward, which animates the clothing.

San Felipe is shown as though crucified, having been stabbed with the two spears depicted in the sculpture, but it is interesting to note that the figure is in fact free-standing, striding forward with arms outstretched as though to embrace the viewer. The effect, as with so much Baroque art, is to remove the distance between object and audience and thus involve the audience in both the pain and the ecstasy of a holy death. One can imagine schoolboys being exhorted to join an order and set off to missionize the world in imitation of San Felipe, and it is also clear how so vivid an image could become the focus of fervent prayer.

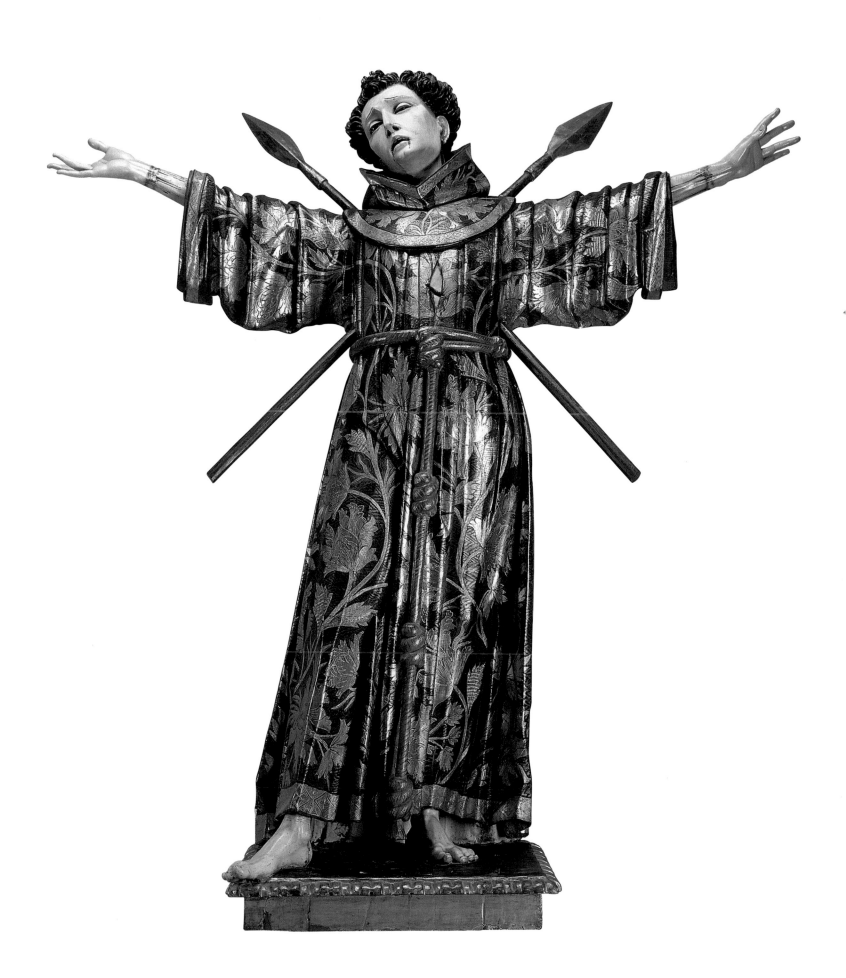

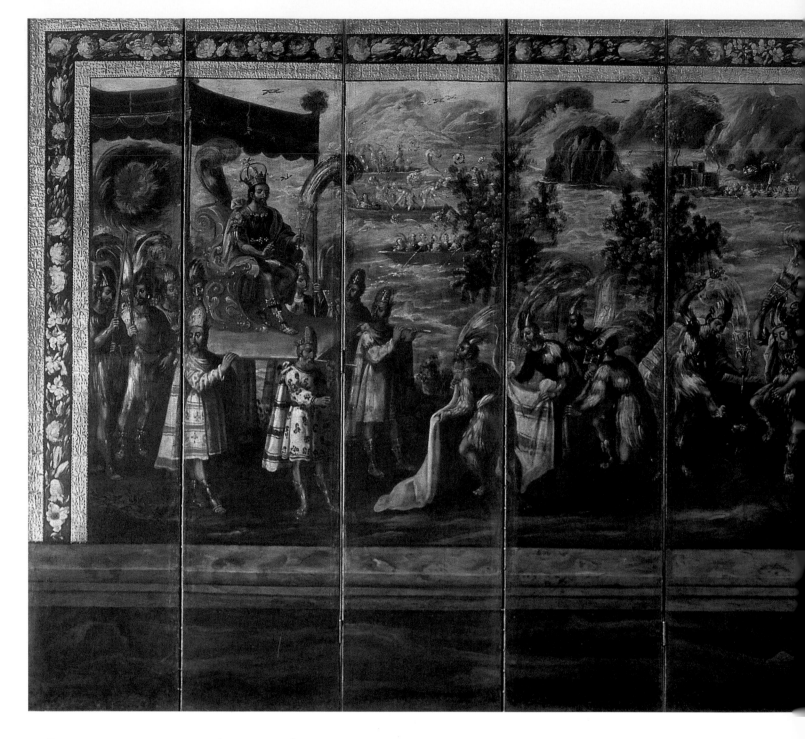

The Meeting of Cortés and Moctezuma
Attributed to Juan Correa (c. 1645/50–1716)

Folding screen *(biombo)*.
Oil on canvas. 8 feet, 2 inches x 19 feet, 8 inches (248.9 x 599.4 cm).
Collection SEDUE, Banco Nacional de Mexico, Mexico City.

Although religious art was undeniably the principal arena of artistic expression in colonial Mexico, secular subjects were not nearly as rare as they are today. Many secular histories, allegories, and fancy pictures were created for ephemeral contexts, such as interior decoration or the triumphal arches set up in Puebla and Mexico City to welcome new viceroys. Nevertheless, an increasing number of landscapes, city views,

depictions of fiestas, and genre subjects, have come to light, allowing us a more complete image of viceregal society.

One type of object that has survived in sufficient numbers to illustrate the secular interests of the colonial leaders and Creole elite is the *biombo*, or illustrated folding screen, such as the example seen here. Typically decorated with historical scenes, battles

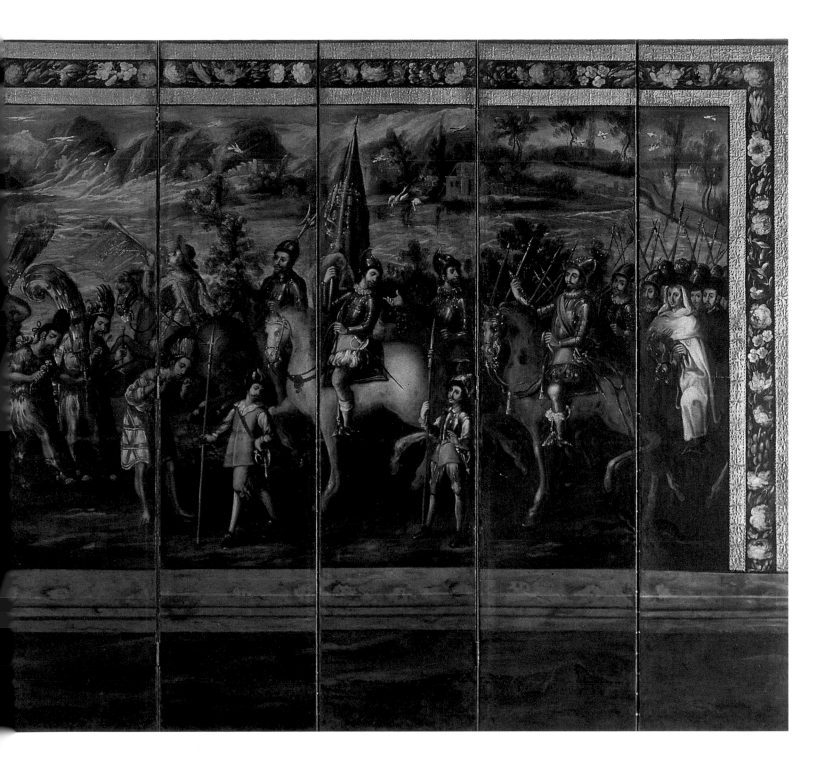

(including those from the Conquest), mythologies, or allegories, *biombos* were both decorative and instructive, combining the function of furniture with the aesthetic of fine art. It was apparently acceptable for a high-ranking master painter such as Juan Correa to take commissions for screens, and the preserved example attributed to him (painted on both sides, but seen here from the front only) exhibits a lavish attention to detail. Fans were another utilitarian object occasionally decorated by the best artists, in Europe as well as the New World.

Correa's style was highly idiosyncratic, with no exact parallel among Old World masters, but his imagery was purely European. While some contemporary pictures, not to mention the codices, depicted the ancient Aztecs with some degree of historical accuracy, Correa's Moctezuma has become a Renaissance-style Roman emperor with feathers. On the reverse, the four continents (or four races) take the standard European iconographical forms, with Europe itself represented by portraits of the Spanish king, Charles II, and his queen. Colonial furniture was sumptuous, and colonial costumes even more so. We must imagine this folding screen to have been the central focus of an interior decoration every bit as luxurious as those in Madrid or Paris.

Monstrance
Signed and dated 1694
Oaxaca
Master PCDAI

Silver gilt with enamel. Height: 27 inches (68.6 cm).
Museo Franz Mayer, Mexico City.

Oaxacan goldsmiths were already famous in Prehispanic times, and their reputation did not diminish with the importation of European techniques and motifs after the Conquest. This was particularly true in the late seventeenth and early eighteenth centuries, when a general economic revival, coupled with a second silver boom spurred by new techniques for extraction from ores, caused a wave of prosperity to sweep over Mexico.

Throughout the colonial era, enormous amounts of highly valued resources were dedicated to the adornment of churches and convents, a particularly rich Baroque decoration characterizing Oaxacan monuments, such as the churches of Santo Domingo (1600s) and La Soledad (1682–1690). An important element to any altar ensemble was a monstrance, or stand, in which a communion wafer was exhibited during ceremonies such as the Benediction of the Blessed Sacrament. Goldsmiths and silversmiths tried to outdo one another in creating magnificent sunburst patterns (symbolizing Jesus, the light of the world, present in the Eucharist) on elegant columnar pedestals called stems, the whole set with enamels and often, precious stones.

In this example, the sunburst itself has two rings, an inner halo magnifying the round shape of the wafer, and an outer ring projecting the design into space.

The monstrance is inscribed "made when Captain Fran[cis]co Prieto Gallardo was mayordomo and the [brother?] de la Rocha y Cazeres priest. PCDAI made it in the year 1694." PCDAI is either an anagram or the initials of the artist who has not yet been identified as any documented silversmith. The artist who created this beautiful piece was obviously a master of extraordinary gifts who belongs among the finest creators of decorative arts.

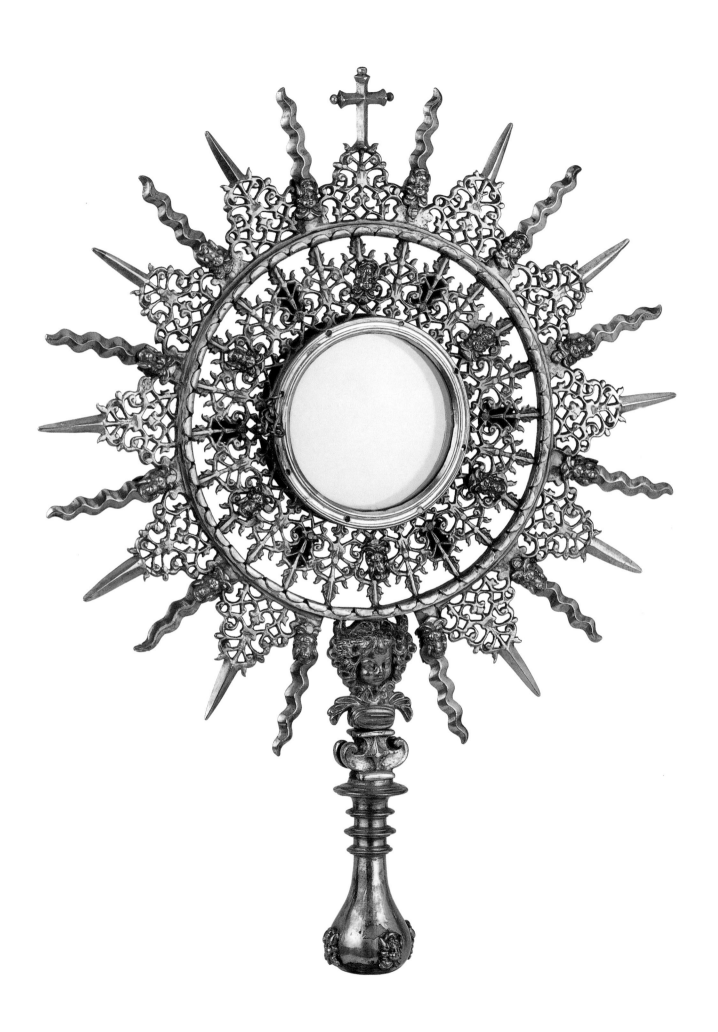

Vase
Early eighteenth century
Puebla

Tin-glazed earthenware. Height: 19 ½ inches (49.5 cm).
Museo Franz Mayer, Mexico City.

Artistic influences from all around the world converged in the city of Puebla in east-central Mexico during the colonial period. Founded as a new Spanish settlement in the middle of one of the most prosperous indigenous regions, Puebla became the second city in the viceroyalty. Elsewhere in Mexico in the ceramics industry, local materials and native traditions were combined with techniques brought from Spain, with widely varying artistic results. At Puebla, another element entered the equation by the early 1600s: the influence of Chinese ceramics. Also called *kraak* or carrack porcelain, after the Dutch word for a type of sailing vessel, Chinese export porcelain revolutionized ceramic production throughout the European world from the late Renaissance through the eighteenth century. Brought to Mexico as ballast in galleons sailing from Manila to Acapulco beginning in 1565, export porcelain and other Oriental products became common in the colony by the 1600s. Simultaneously, imports of lusterware from Manises near Valencia as well as the more Italianate products of Talavera de la Reina near Toledo continued steadily.

By the mid-1600s, Puebla's potters had developed the tin-glazed earthenware for which the city is famous. Known variously as Puebla majolica or even "Talavera de Puebla" (the name, "Talavera" having become generic, like "Kleenex" or "Xerox"), Puebla ware exhibits a thick, deep blue, cobalt in-glaze decoration that sits on the off-white tin ground almost like jelly, and that was used in many different compositional ways. Although black and brown colors were also used, and a fully polychromed ware developed in the eighteenth and early nineteenth centuries, it is the blue and white pieces that define the Puebla style.

This vase is derived from K'ang-hsi period (1661–1722) export porcelain vases, or similarly shaped snuff bottles, preserving the blue and white traditions of earlier Ming dynasty porcelains (1368–1644). The Mexican potter has paid careful attention to the effects of increased scale and the translation of the decoration into the thicker earthenware medium. The running plant stems and lotus blossoms are extremely close to those on surviving export pieces and may represent a direct copy from a Chinese model.

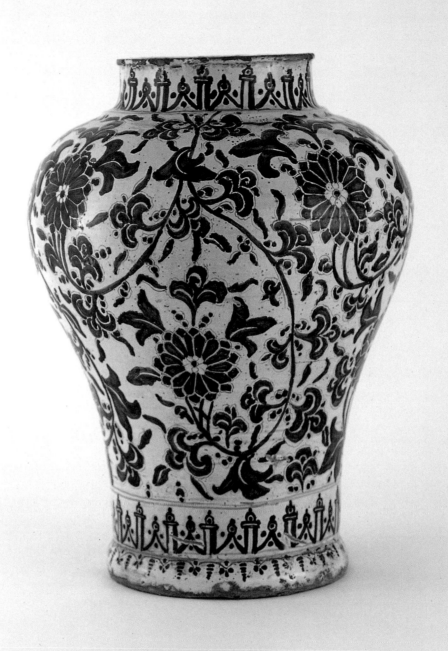

Doña María de la Luz Padilla Y (Gomez De) Cervantes
Signed and dated 1760
Miguel de Cabrera (1695–1768)

Oil on canvas. 43 x 33 inches (109.2 x 83.8 cm).

Brooklyn Museum of Art, Museum Collection Fund and the Dick S. Ramsay Fund (52.166.4).

Doña María de la Luz Padilla y Cervantes (1732–1789), handsome, clever, and rich, lived the first twenty-five years of her life with very little to worry her, although one would never know it from the stern expression she habitually wore on her face. Even as a little girl, she cultivated this sour look, to judge from extant portraits. At about the time this likeness was taken, she was about to marry, or perhaps had just married, her cousin, Don José Leonel Gómez de Cervantes; their descendants would continue marrying into other prominent Creole and Spanish families well into the twentieth century.

We know all this about Doña María because a nearly complete set of family portraits found its way intact into the collection of the Brooklyn Museum. Viceregal portraiture is extremely rare outside of Mexico itself, and to have what amounts to a family tree is therefore highly unusual. The Padillas and the Cervantes were enormously wealthy, and they took care to dress their favorite daughter in the very latest fashions from Madrid and Paris. Indeed, Spanish court portraiture from about 1750 shows exactly the same lines, but even a princess royal could not hope to match the spectacular Chinese-style silk embroidery on Doña María's dress or the quantities of pearls, white sapphires, and diamonds dripping off her neck and wrists. This was an age in which a wealthy Creole mine owner at Guanajuato might pave the street from his house to the church with silver ingots in honor of his daughter's marriage! As for the silk, it may have been Mexican, too, since the colony developed an advanced silkworm industry, although fine textiles continued to be imported directly from China. The immense brooch, apparently set with diamonds, on her bodice was probably detachable; it may have been an heirloom, since it seems to follow the style of a generation earlier.

Miguel de Cabrera, a *mestizo* (person of mixed Spanish and indigenous race) was born in 1695 and raised by his godfather at Oaxaca, coming to Mexico City in 1719. Once there, he absorbed the European style of Juan Rodríguez Juárez (1675–1728/32) and continued throughout his career to interact with the late Baroque manner of José de Ibarra (1688–1756), Rodríguez Juárez's follower. Cabrera served as court painter to the Archbishop Rubio y Salinas (1749–1756), led the group of Mexican painters who examined the image of the Virgin of Guadalupe in 1751, and joined Ibarra in founding a short-lived academy in Mexico City. At mid-century, the large Cabrera workshop dominated artistic production in Mexico, so that it is sometimes difficult to separate works by his hand from those of his followers.

Cabrera's formal court portraits, in contrast to his genre pieces and less formal likenesses, disappoint the viewer in psychological terms. There is a tendency for the clothes to make the person, which is of course what his sitters probably wanted. Still, how glorious those costumes are, and it takes only a little imagination to visualize Doña María and her cousin leading the minuette at their wedding ball.

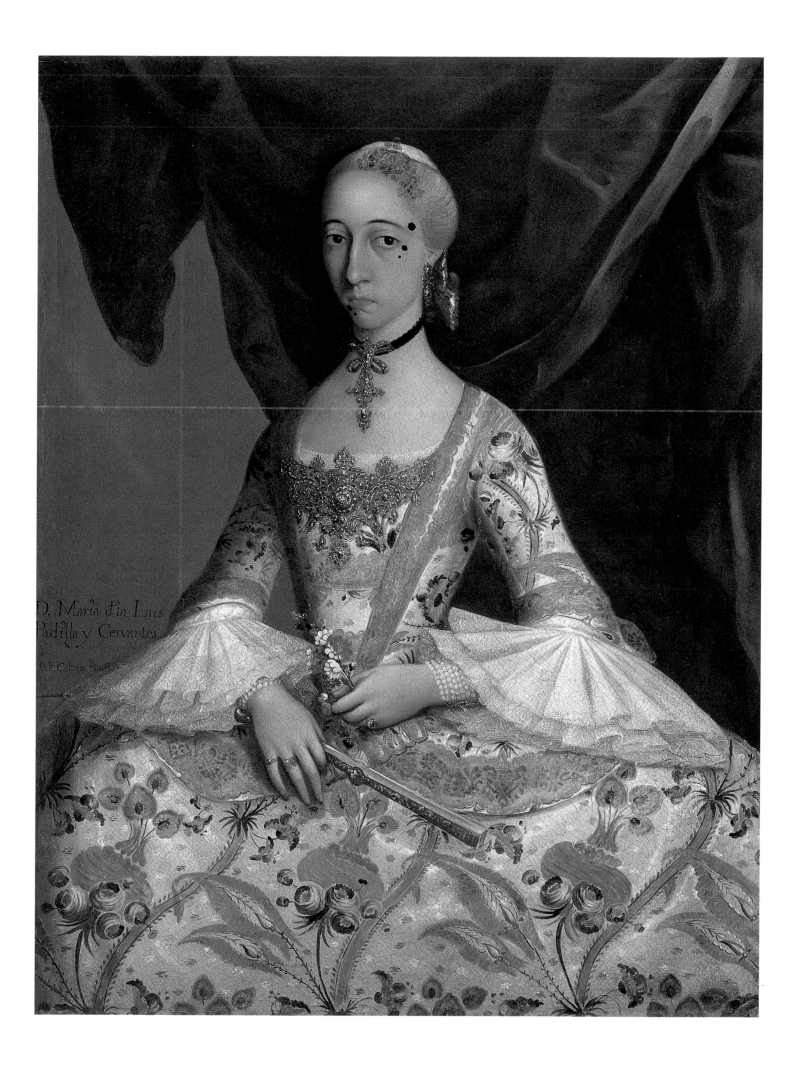

D. Maria dla Luz
Padilla y Cervantes

Mich.l Cabrera Pin.

The Sculptor Manuel Tolsá

c. 1794–1796

Rafael Jimeno y Planes (1759–1816)

Oil on canvas. 40 ⅛ x 32 ¼ inches (101.9 x 81.9 cm).
Pinacoteca Virreinal de San Diego, Mexico City.

Around 1755, two new movements in European art began to change the Old Master tradition that flowed out of the Renaissance into the seventeenth and eighteenth centuries. Neoclassicism and Romanticism, two sides of the same cultural coin, emerged, and today are recognized as the first styles of the modern era. The impact of Neoclassicism was particularly great in Mexico, where the Real Academia de San Carlos en Nueva España was chartered in 1781–1785. Neoclassical projects changed the shape of Mexico City, bringing an entirely new simplicity to church interiors, creating imposing buildings, and giving birth to some of the most ravishing decorative arts pieces ever made.

Rafael Jimeno (or Ximeno) y Planes was born in Valencia in 1759 and trained at the Academy of San Carlos there, as well as at the Fine Arts Academy of San Fernando in Madrid from 1774, where he, like all other ambitious young artists, came under the influence of the Bohemian Neoclassicist, Anton Rafael Mengs (1728–1779), and Francisco Bayeu (1734–1795), Mengs's associate and Goya's brother-in-law. Jimeno was named director of painting at the Mexican Academy of San Carlos in July 1793 and arrived in Mexico City in May 1794. He was general director of the academy from 1798 until his death in 1825.

One of the most important professors at the new academy was Manuel Tolsá, born near Valencia in Spain in 1757. He was made director of sculpture at the Mexican Academy in September 1790, arriving in July 1791 along with a large library and a collection of plaster casts, some of which remain in service today. He died in Mexico in 1816 after exerting an enormous influence as an architect, sculptor, designer, and teacher.

Tolsá appears here dressed as a gentleman, with a modeling stylus, the symbol of his profession, in his proper left hand. The pose finds precedents in a long line of classical portraits, including Francisco Goya's Neoclassical *Portrait of Sebastián Martínez* of 1792 (Metropolitan Museum of Art, New York), which Jimeno may have seen in Cádiz on his way to Mexico, as well as in Diego Velázquez's *Portrait of the Sculptor Juan Martínez Montañés* (Museo del Prado, Madrid; 1630s). The completely up-to-date nature of the composition reminds us once again how in touch viceregal Mexico was with the latest European developments.

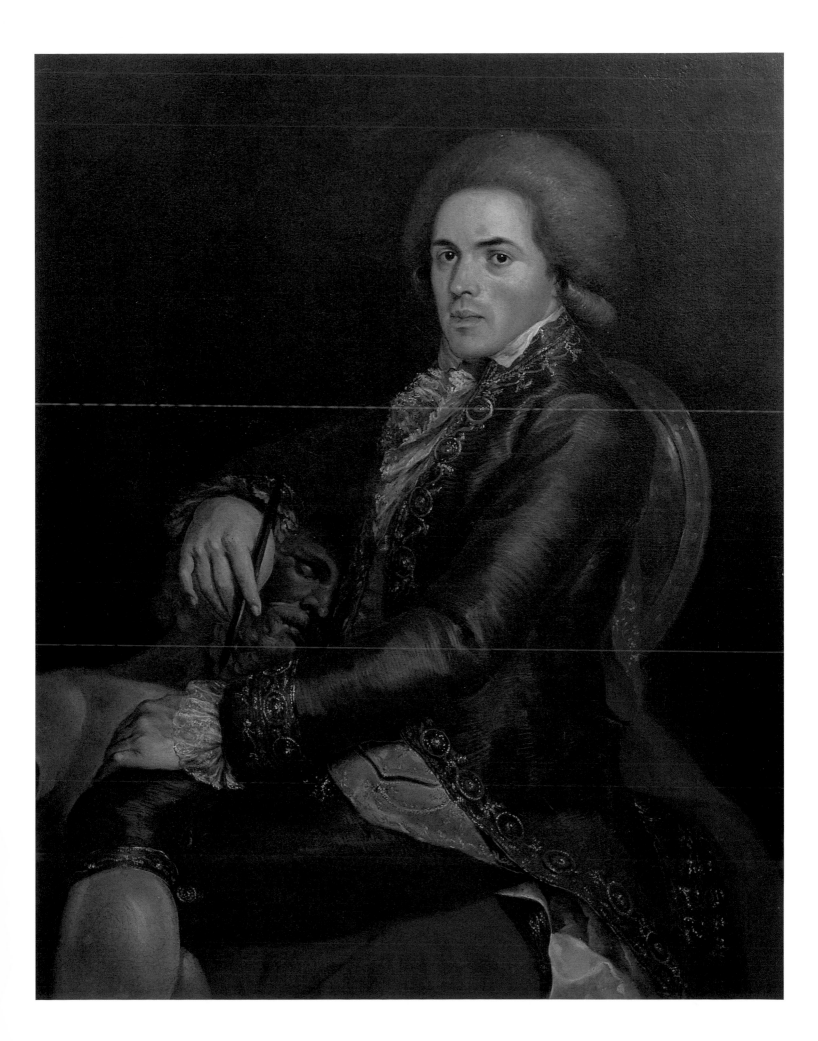

The Dead Poet (Don Francisco Torres)
Signed and dated 1846
José María Estrada (active 1830–1860)

Oil on canvas. 16 ½ x 12 ¼ inches (41.9 x 31.1 cm).
Museo Nacional de Arte, Mexico City.

In colonial Mexico, young nuns who had passed the rigors of the novitiate were often adorned with elaborately brocaded capes, richly framed devotional images, and crowns made of brightly colored papers and flowers at the time they were to take their final vows. Often, this moment was commemorated in a portrait, presumably intended for the new sister's family; images of this type are called *monjas coronadas*, "crowned nuns." In some convents, the crowns and other devices were put away, to be reused in funeral rites, and there exist a few posthumous images showing particularly revered nuns on their biers, attired as on the day of their profession. The Prehispanic roots of this tradition were very deep, since flowers held a special place in Mesoamerican culture.

A separate tradition assigns a crown of leaves, particularly laurel leaves, to the heads of poets and other writers, as in the expression, "poet laureate." Dante, for example, is inevitably depicted with a laurel crown. The sense of immortality attached to the laurel and certain other plants in European culture also suggested a connection with death, as expressed in the elegy that John Milton (1608–1674), the famous British poet, composed on the death of a beloved friend:

Yet once more, O ye laurels, and once more,
Ye myrtles brown, with ivy never sere,
I come to pluck your berries harsh and crude,
And with forced fingers rude
Shatter your leaves before the mellowing year.
Bitter constraint, and sad occasion dear,
Compels me to disturb your season due;
For Lycidas is dead, dead ere his prime,
Young Lycidas, and hath not left his peer.

Like Milton, the Mexican provincial painter José María Estrada had lost a friend, the poet Francisco Torres, taken "before his prime." And like Milton, Estrada turned to his own art to immortalize the departed. Estrada, about whose training we know little, worked in Guadalajara, Jalisco, in a style that is at once naive from an academic point of view yet enormously powerful and even sophisticated in terms of artistic communication. Here the dead poet is presented as though sitting, his eyes closed perhaps in the act of composing a line of poetry, at once conveying the ideas of death and of inspiration. Estrada has effectively combined the tradition of *monjas coronadas* with that of the poet laureate, creating a painted elegy for his lost companion.

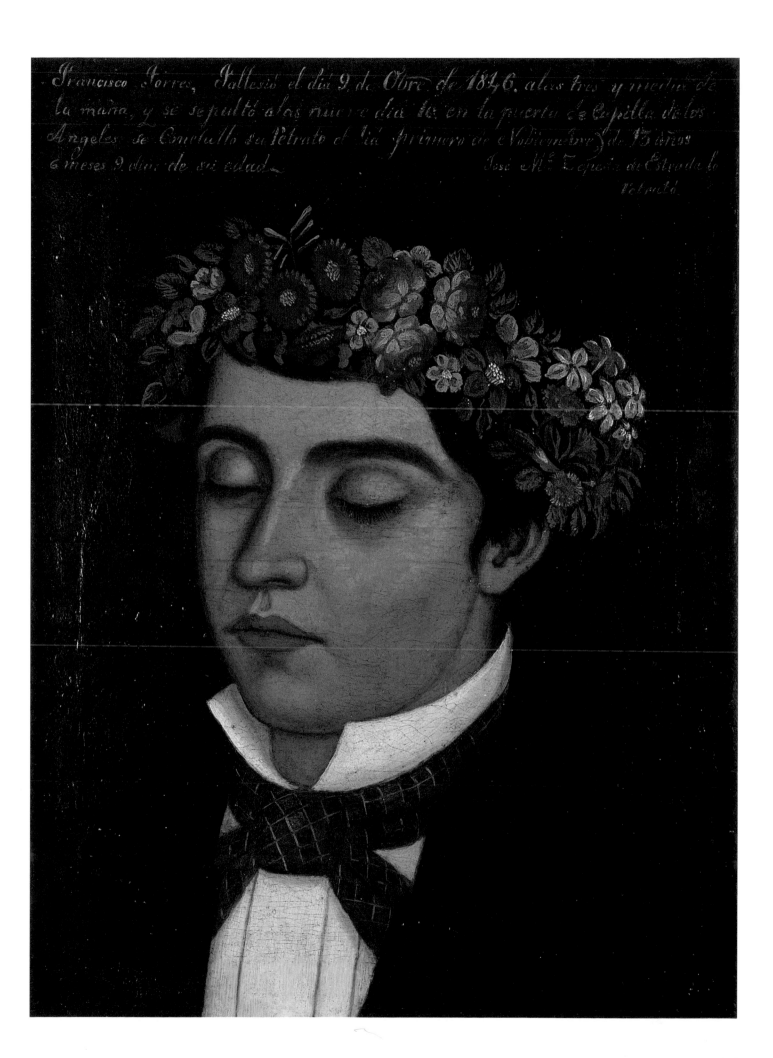

The Discovery of Pulque
1869
José María Obregón

Oil on canvas. 74 3/8 x 90 1/2 inches (189 x 229.9 cm).
Museo Nacional de Arte, Mexico City.

Pulque is an intoxicating drink, similar to beer or wine, fermented from the sap of a type of agave plant; a slightly different agave yields the fermented liquid distilled into tequila. A powerful intoxicant, pulque played an important role in Prehispanic ritual and society, and was closely regulated in ancient Mesoamerica, with the Aztecs going so far as to impose the death penalty for abuse. During the colonial period, the drink was in effect rationed to authorized buyers, who either had to appear in person at the pulque shop (pulquería), or send a special container. Some of these have charming inscriptions: "He who cannot come himself sends this jug to the pulquería." Like wine in the ancient European world, pulque was the stuff of legend, its power to intoxicate, to take the drinker to a different level of consciousness, somehow sacred.

As with so many of the practices the Aztecs inherited from previous Mesoamerican civilizations, they assigned the discovery of pulque to the Toltecs. According to legend, a young maiden named Xochitl ("Flower") discovered fermenting agave sap. She was taken by her parents to the court of Tecpancaltzin, king of Tula, where her beauty so impressed the king that he took her for his wife.

It is this story that José María Obregón has chosen to illustrate. Born in Mexico City, Obregón, like many of his contemporary Mexican artists, applied a late Romantic version of the Neoclassical style to subjects taken from Prehispanic history. In other words, Obregón sought to unite his European-based academic training with a desire to celebrate his own national history and values. In effect, this meant presenting Prehispanic culture in the guise of ancient Greece and Rome, and indeed, like Juan Correa's Moctezuma two centuries earlier, Obregón's Tecpancaltzin is in effect a Roman emperor, his court the ancient Senate, and Xochitl, as the Mexican scholar Xavier Moyssén observed, a vestal virgin.

This celebration of the antiquity of Mexican civilization, by equating it with the Old World, was a particularly significant idea in 1869, since just two years earlier an independent Mexican Republic had been reestablished after the French imposed reign of the Emperor Maximilian (1864–1867). Here also are the beginnings of *indigenismo*, the movement throughout Latin America that would promote native subjects as the only appropriate imagery for modern art.

One question remains: why pulque? And why so decorous a scene to celebrate a drink that Mexican society had feared and regulated for nearly two thousand years? The answer lies in part in contemporary moral interpretations of the Xochitl-Tecpancaltzin story, which attributed the decadence of the Toltecs to the introduction of pulque at their court. Even more important, however, are the economic implications related to policies promulgated by Benito Juárez (and continued by President Porfirio Díaz, the long-term ruler of Mexico at the end of the century). The brewing industry in general, and the manufacture of both pulque and, eventually, tequila in particular, played an important role in the nineteenth-century Mexican economy. The effects of pulque, from the point of view of the patron class, were not simply a matter of inebriation. Indeed, nearly 150 years later, beers and liquors are still among Mexico's most important exports, endowing Obregón's charming image with a socially prophetic quality.

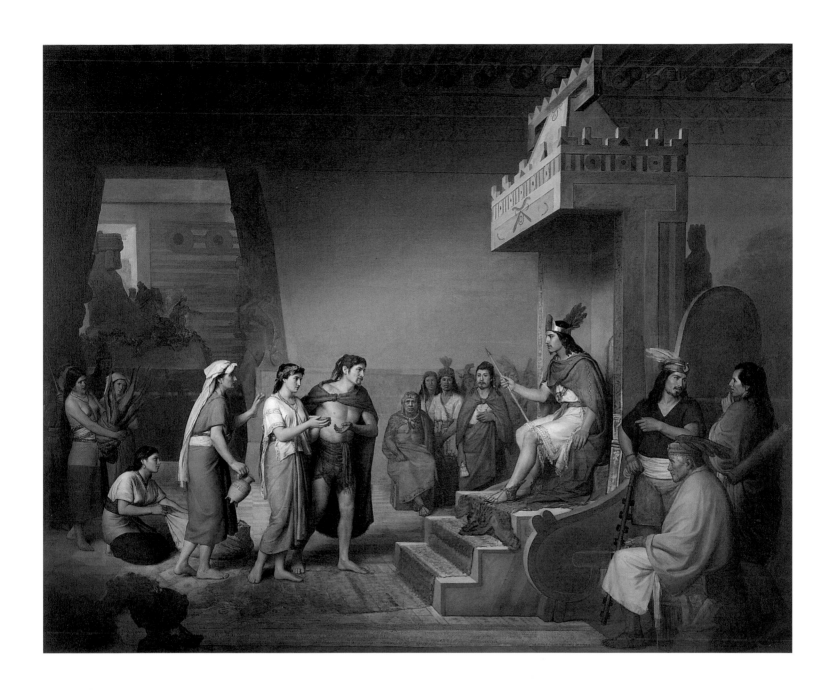

Still Life with Watermelon
1879
Hermenegildo Bustos (1834–1907)

Oil on canvas. 16 ⅛ x 13 ³/₁₆ inches (41 x 33.5 cm).
Museo Nacional de Arte Moderno, Mexico City.

Hermenegildo Bustos (1834–1907) lived his entire life in the small town of Purisima del Rincón near the provincial Mexican city of León, Guanajuato. He studied briefly with an artist named Juan N. Herrera in León, but always described himself as an amateur, earning his living in a variety of ways other than his painting. A master of great genius, Bustos was able to approach his works not only with the directly expressive values of folk art but also with the remarkable powers of observation. Bustos's more ambitious portraits show that he studied the works of more academically trained artists, and he was able, by virtue of both hard work and inborn gifts, to achieve a naive but entirely convincing conquest of visual reality.

The *Still Life with Watermelon* is one of a pair of still life compositions, the other entitled *Still Life with Pineapple*. The purpose of these pieces is not known; they may have been intended as exercises and catalogs of motifs to be used in future compositions. In both paintings, local fruits and vegetables (of both Old and New World origin) are meticulously rendered against a white ground. The fruits are lined up in registers, with each row depicted as though it were a separate composition. To judge from the shadows, most of the fruits are seen from the side, although a few, especially the larger pieces, are shown as if from above. The effect is somewhat surreal, since the fruits tend to hover against the ground when viewed as a group yet possess a palpable reality viewed one by one.

The pictures may be understood as part of a long tradition of scientifically descriptive still life in Latin American art. From the early years of colonization, reports sent back to Spain often included illustrations of local flora and fauna. Given the eighteenth-century interest in science, meticulously depicted fruits and vegetables found their way into genre pictures. And in the late eighteenth century, numerous European and American scientific expeditions, such as those led by Cook and Humboldt sent to describe and catalog local natural phenomena, almost always included artists. The resulting images are invariably fascinating, forming an important subcategory of American (including Latin American) art.

Unlike many contemporary still lifes with their neo-Baroque luxury of over-laden tables, Bustos's *Still Life with Watermelon* creates the effect of some sort of botanical display: lush, but simple and direct, or as Shakespeare put it, "rich, not gaudy." Bustos also made and sold sherbets for a living. Like his ices, *Still Life with Watermelon* clears the visual palette even as it stimulates the appetite.

Finally, the fauna in the picture, a frog and a scorpion, add disconcerting notes among all the tasty snacks. Mexican culture's obsession with death is not lost here; even Bustos's self-portrait shows the artist dressed in the uniform of a burial society. Perhaps the artist intended the scorpion as a *memento mori* ("reminder of death"), or at least a warning not to let our appetites run away with us.

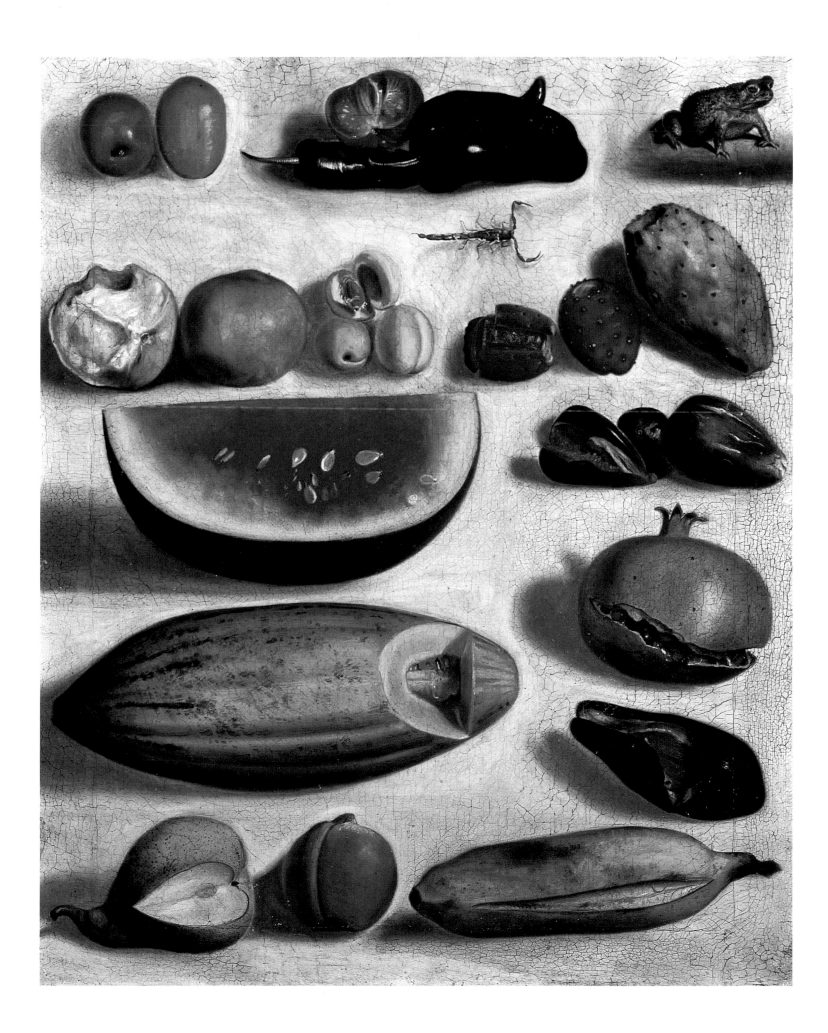

The Valley of Mexico

1875

José María Velasco (1840–1912)

Oil on canvas. 61 ¾ x 89 inches (157 x 226 cm).
Museo Nacional de Arte, Mexico City.

José María Velasco is universally acknowledged to be the greatest Mexican painter of the nineteenth-century, and among the greatest contemporary artists active worldwide. Born at Temascalcingo near Mexico City, Velasco trained under Eugenio Landesio (1810–1879), the Italian *plein air* ("open air") realist who established landscape painting at the Mexican Academy.

In addition to a detailed realism and careful observation of the role of light and color in landscape, Landesio taught painterly values derived from the great seventeenth-century masters, above all Claude Lorraine (1600–1682), whose golden-hued compositions, at once classical and luminous, influenced a wide variety of artists internationally. Against this academic background, Velasco added strong scientific interests. He was not only a naturalist-painter and photographer but also published scientific articles on biological topics and had a great many extra-artistic interests. Exhibiting at numerous international exhibitions, including Chicago, Philadelphia, and several other United States venues, as well as Paris, Velasco was one of the first universally recognized Mexican artists of the modern period.

Early Romantic landscape, with its evocation of the sublime, soon became bound up in the celebration of national values, and nowhere more forcefully than in the North American works of artists such as Thomas Cole, Frederick Church, Albert Bierstadt, and Thomas Moran—all of them Velasco's older contemporaries. Romantic nationalist works often used Baroque techniques, including the contrast of light and dark, a dynamic composition, and subject matter chosen for its pictorial shock value, to conjure up the power of Nature and a spirit of place. European *plein air* realism advanced, however, a more objective point of view in harmony with nineteenth-century science, leading eventually to Impressionism.

Velasco's genius lies in his ability to combine an incredible range of influences successfully. From Lorraine and the classic masters of the past, he derives a sense of geometrical order and luminous play of light. Baroque touches are included (storm clouds pass, rocks are cast into shadow, and the whole has a panoramic sweep that is just short of cinematic), but they are subordinated to a sense of scientific detail at one extreme and compositional discipline at the other. The incomparable Mexican landscape is celebrated, but the artist never omits the cities and other works of human hands, and is careful to include figures to reinforce the humanistic values of his style. Many Romantic landscapes take one's breath away; Velasco's works do so, too, but they also hold one's interest, offering an artistic experience at once precise and universal.

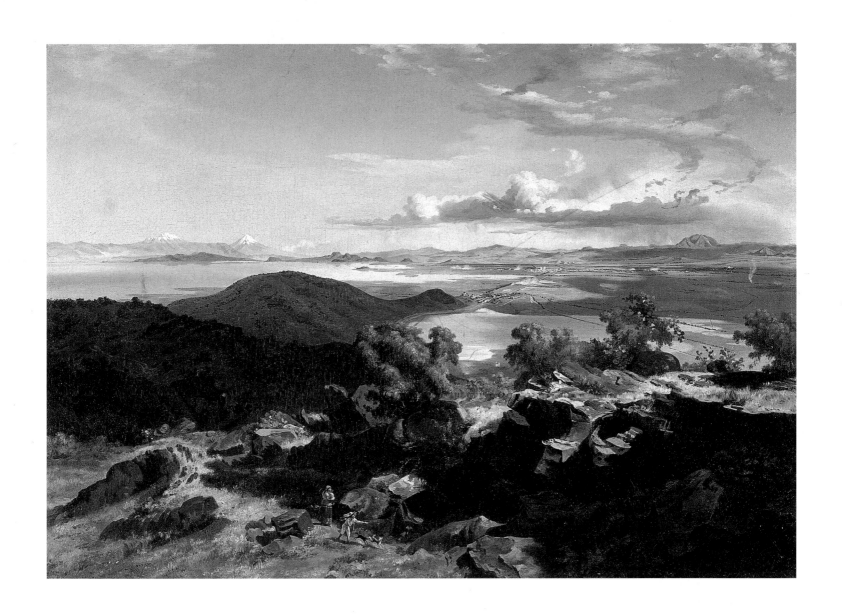

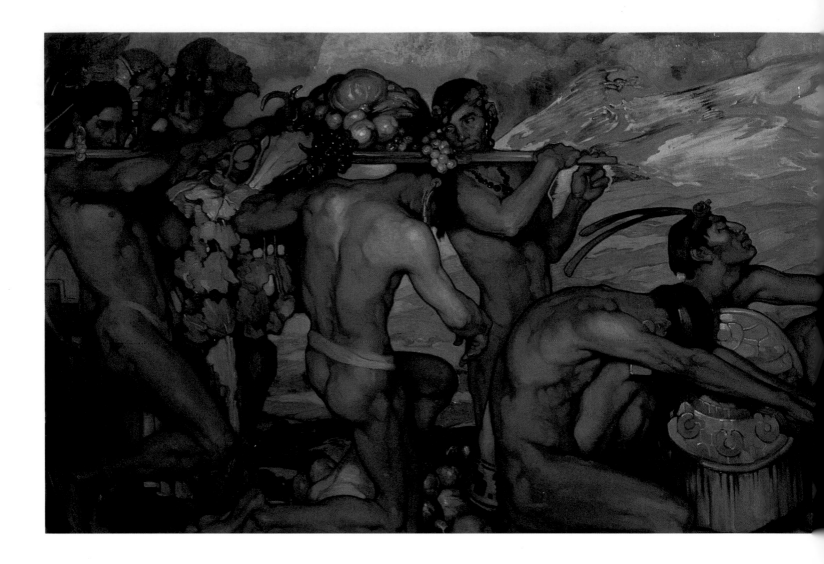

Our Gods
1918
Saturnino Herrán (1887–1918)

Oil on canvas. 5 feet, 9 inches x 17 feet, 5 inches (175.3 x 518.2 cm).
Private Collection.

Saturnino Herrán, born in 1887, found his first training in his hometown of Aguascalientes. At the age of sixteen, he moved to Mexico City with his widowed mother and attended classes at the Mexican Academy. He was hired to make copies of Prehispanic art at Teotihuacán for the Archaeological Monuments Survey in 1907, sparking his interest in ancient murals. An important exponent of *indigenismo* (the depiction of indigenous Mexican life), he also taught drawing at the National Normal School for Teachers. His premature death in 1918 at the age of thirty-one was one of Mexican art's most tragic losses.

The *Our Gods* project began in 1914 with a competition at the Academy for a mural to be placed at the new National Theater (Palacio de Bellas Artes), still under construction. Eventually, Herrán decided to paint a large triptych, with a group of Prehispanic Indians on the left doing obeisance towards a proposed central panel, which was intended to depict the Aztec cult statue of Coatlícue merged with a crucified

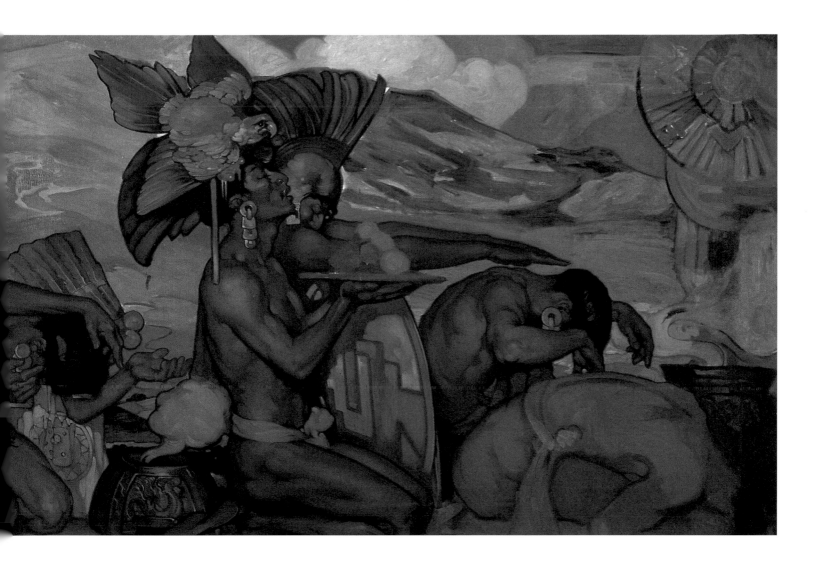

Christ. Behind the Indians, the snow-covered volcano Ixtaccíhuatl ("the sleeping woman") catches the light. On the right, Spanish monks, priests, and conquistadors were to do homage to the crucifix. A number of studies gave testimony to the entire project; only the left panel, illustrated here, was largely completed before Herrán's untimely death.

Our Gods displays Herrán's every virtue: a facile command of human anatomy; luscious, fluid handling of paint; a fascinating play of light; vivid presentation of psychological states and human interaction; and a surprisingly abstract overall effect that places him in the ranks of proto-modernists. As Jacinto Quirarte has observed, the Indians are grouped into wavelike bunches, creating an undulating energy that moves

from the left towards the right margin, where the panel with the Coatlícue/Crucifixion was to be placed. The visual "waves" would therefore have crashed against the massive form of the ancient idol and balanced a similar wavelike flow moving from right to left across the groups of Spaniards. The composition was therefore designed to mount to a visual crescendo at the hybrid Aztec-Christian image. The *Our Gods* project provides a bridge from the Romanized Prehispanic subjects of the nineteenth-century academics (such as Obregón's *Discovery of Pulque*) to the muralist movement in the next decade. Had he lived, Herrán would have surely made important further contributions to muralism and to Mexican art in general.

Paracutín
Signed and dated 1945
Dr. Atl (Gerardo Murillo, 1875–1964)

Oil on composition board. 27 1/2 x 38 3/8 inches (69.8 x 97.5 cm).
Private Collection.

Few Mexican artists have had the lasting influence of Gerardo Murillo, who painted under the pseudonym, "Dr. Atl," (from the Nahuatl [Aztec] word for "water"). Atl was born in Guadalajara in 1875 and studied painting there and in Mexico City before going to Europe to study philosophy and law in 1897. While there he traveled widely, observing the Old Masters and absorbing the principles of Impressionism. He returned to Mexico in 1903 and began teaching at the Fine Arts Academy of San Carlos; Rivera, Orozco, and Siqueiros were among his students. During the Revolution and Civil War, Atl studied volcanology in Europe, but returned to Mexico to become Venustiano Carranza's propaganda minister from 1913 to 1915; among the artists working for him were the painter Francisco Goitia (1886–1969), as well as Orozco and Siqueiros. Throughout his career, Atl was a tireless organizer of exhibitions and an enthusiastic student of the Old Masters and contemporary European movements, but always subordinated internationalist interests to a sense of Mexican identity.

In the 1890s, landscape painting at the Academy was still under the spell of José María Velasco's blend of precisely detailed *plein air* naturalism and panoramic classical design. Atl's expression of this tradition was more Impressionist and Symbolist, but always remained rooted in reality. In 1943, the landscape of Tarasco found a new reality: the emergence, from a cornfield, of the volcano Paracutín. Atl rushed to the scene, documenting, practically on a moment-to-moment basis, the creation of a new bit of Mexico. The result was some of the most extraordinary imagery in Mexican painting.

Atl took Paracutín as a personal archetype and a symbol of the emergence of the modern Mexican nation. He was hypnotized by the spectacle of the exploding lava, which he has contrasted in this example with the gray of the ash-covered landscape around. The works are by necessity dynamic, and every touch, such as the swirling brushwork in the dark clouds, adds to the effect. Atl's fascination with volcanoes lives on in other works in his Paracutín series, where he may augment the composition with surprisingly pastel-like Post-Impressionist color harmonies.

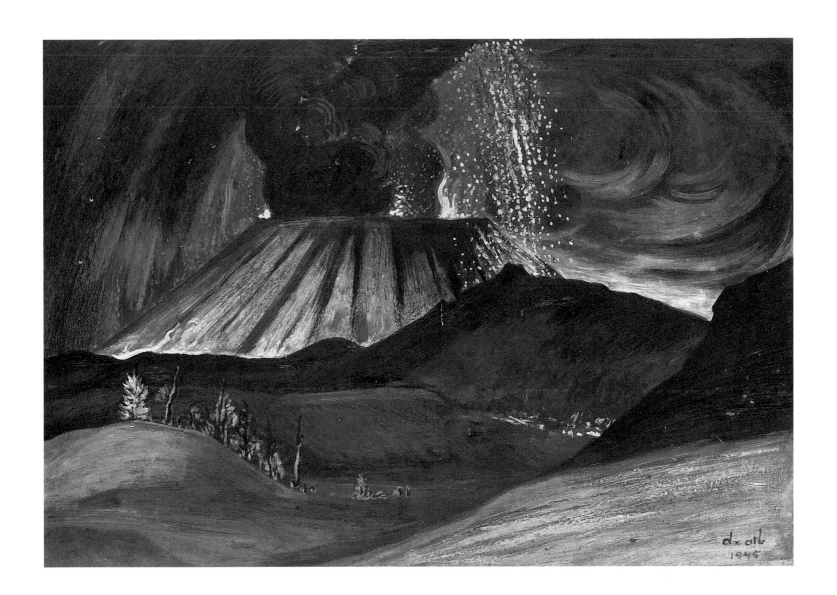

Zapatista Landscape
1915
Diego Rivera (1887–1957)

Oil on canvas. 56 ⅝ x 48 ½ inches (144 x 123 cm).
Museo del Palacio de Bellas Artes, Mexico City.

Twentieth-century Mexican art has deep roots in European Modernism. This is nowhere more apparent than in the career of Diego Rivera (1886–1957), arguably the most important twentieth-century Mexican painter.

Rivera went to study in Spain under Eduardo Chicharro in 1907. While there, he absorbed influences from El Greco and the Spanish proto-modernist Ignacio Zuloaga, as well as from the more avant-garde members of the Spanish literary "Generation of '98," including Pio Baroja and Ramón Valle-Inclán. He came to Mexico City for a one-person exhibition in November 1910, but returned to Europe in 1911, just as the Mexican Revolution was heating up. Alternating between Toledo, Spain, and Paris, Rivera became increasingly involved with Cubism. Rivera returned to settle in Paris in late summer, 1913, where his friends included the Mexican avant-garde painters Angel Zárraga and Adolfo Best-Maugard, as well as Jacques Lipschitz, Amadeo Modigliani, and a group of Russians, especially the writer Ilya Ehrenberg.

In the Spring of 1914, Rivera finally met the man whom he called his "master," Pablo Picasso. Their personal relationship was complicated—artistic rivalry once brought them close to blows—but their painterly interchange was decisive. Picasso had provided Rivera with the Cubist artistic vocabulary, a new way of seeing and creating. In return, Rivera reinvigorated the movement with new ideas and techniques and strong support for Juan Gris's expansion of the Cubist vision into landscape.

In the hands of Picasso and his collaborator, Georges Braque, Cubism began as an analytic approach. Motifs taken from Nature, including still lifes and portraits, were simultaneously presented from several viewpoints, as though distinct representations had been painted on stained glass, broken into shards, and reassembled on a diagonal grid. By 1914, however, Picasso, Braque, and Gris had moved into a second phase, Synthetic Cubism, in which fragments of motifs were assembled into a composition that "synthesized" reality. It is this technique which Rivera uses in *Zapatista Landscape*.

The *Zapatista Landscape* had meaning for Rivera far beyond its stylistic origins. Separated by an ocean from the increasingly bloody, chaotic Civil War in Mexico, and surrounded by a Paris embroiled in World War I, Rivera used the making of *Zapatista Landscape* to come to grips with who he was. The Mexican objects in the picture, including the large hat, the colorful serape, and the rifle, were the emblems of the radical Mexican general, Emiliano Zapata, for whom Rivera claimed to have fought briefly in 1911. Rivera probably made up the story, but the work of art nevertheless proclaimed his new allegiances. No longer the dutiful son of progressive, bourgeois technocrats in the régime of Porfirio Díaz, Rivera now cast his lot (artistically) with the radicals, the reformers, not to mention the Marxist-Leninists among his Russian friends, yet he also affirmed his Mexican roots.

Furthermore, *Zapatista Landscape* bridges the gap between Rivera's academic training and his avant-garde career. He spoke of the picture as a "trophy"—that is, a classical composition in which military objects are piled up symbolically—and the work clearly reflects his studies with Velasco as well. The overtly Cubist aspects in the picture would not be found in many of Rivera's subsequent paintings, but the combination of Modernist techniques, political statement, popular motifs, and traditional, even academic artistic forms would continue in his work for the rest of his life.

Detroit Industry, South Wall
1932–1933
Diego Rivera (1887–1957)

Mural decoration for the Garden Court, Detroit Institute of Arts.
Fresco, painted in situ.
The Detroit Institute of Art, Detroit, Michigan. Gift of Edsel B. Ford.

In 1931, the Detroit Commission for the Arts, under the leadership and financial support of Edsel Ford, invited Diego Rivera to paint murals in the Garden Court of the Detroit Institute of Arts. The director of the Institute (actually a municipal art museum) was Dr. William R. Valentiner, one of the most important cultural figures in the United States during the 1930s, and clearly active in bringing Rivera's achievements as a muralist to the attention of the selection committee. The resulting ensemble maintains a secure place among the most important monumental works of art in the twentieth century and is arguably Rivera's finest achievement.

Rivera began to paint on June 25, 1932 and finished on March 13, 1933, exhausted and nearly one hundred pounds lighter than when he began. (His six-foot frame typically carried as much as 350 pounds, so he could afford to lose the weight.) Although he had been enthusiastically welcomed by Valentiner, Ford, and many other members of Detroit's artistic community and social elite, he nevertheless found himself in a difficult position from the standpoint of his political beliefs. An ardent socialist, ex-communist, and vociferous radical, Rivera came to a Detroit wracked with labor strife and ravaged by the Depression. Rivera had to find a way of expressing his solidarity with and hopes for the common worker while at the same time celebrating the dynamism of the city, including the contributions of the managerial class and patrons who had hired him to paint.

The Garden Court, a Renaissance-revival covered patio, rectangular in plan and two stories in elevation, was located within the museum building and was planted with lush tropical vegetation as a retreat from the hubbub of the industrial city. Rivera, in effect, brought the hubbub inside, creating two huge panoramas of the inside of automobile factories set in the context of a complicated allegory of hope for modern technology, industrial production, and human labor.

The principal images are found on the longer north and south walls, the latter illustrated here. At the top, four immense figures symbolize the four races (or continents) above friezes depicting mineral-bearing strata within the earth. The north figures—black Africa and copper- or rust-colored indigenous America—hold coal and iron ore respectively, these being the two ingredients necessary for creating the steel of the automobiles. Below, the large industrial scene features fiery hearths in the background for the production of motor blocks. On the facing south wall, the white (Caucasian) race and the yellow (Asian) race hold limestone/chalk and sand, both essential for steel casting, although the limestone was intended to refer to pharmaceuticals and the sand probably to the glass industry. The large lower area depicts an assembly line.

The mechanized dehumanization of workers was a common theme in art from 1900 to 1940. Cubist, Futurist, Dada, and Surrealist masters all created images hybridizing human and mechanical details, as did the cinema from Fritz Lang's *Metropolis* (1926) to Charlie Chaplin's *Modern Times* (1936). Both north and south murals show huge stamping machines, such as the one to the right in the illustration. These bear an uncanny (and intentional) resemblance to the Aztec cult statue of Coatlícue. The implication might be that the Detroit autoworkers are a type of human sacrifice on the altar of efficiency, and indeed, the humans tend to get lost in the tangle of machinery and air-handling equipment.

In sum, however, the murals offer more a celebration of the industrial environment than a condemnation, the idea being that labor is creating a new culture.

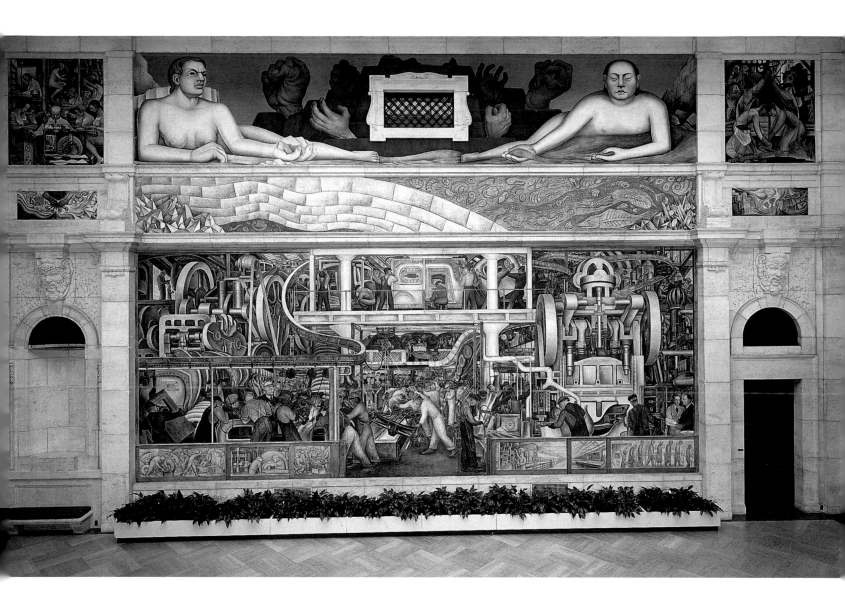

The workers, scientists, engineers, and administrators appear engaged in a heroic struggle to wrest new material benefits from what were once raw materials. Indeed, between each pair of colossal figures at the top, powerful hands emerge from small mounds of earth. These constitute a visual pun in Spanish, for which *mano de obra* (literally, "hand of work") means "labor."

Although clearly dependent on Cubist compositional devices and indebted in a general way to Cubism's Italian cousin, Futurism, Rivera's scenes are also anchored firmly in reality. At the same time, the top-heavy overall composition, with the enormous symbolic figures in the upper register, contains the dynamism of the industrial scenes and conveys a sense of permanence beyond the scurrying concerns of the moment.

Dance at Tehuantepec
1928
Diego Rivera (1887–1957)

Oil on canvas. 78 x 63 ¾ inches (198 x 161.9 cm).
Private Collection.

For Mexicans, the customs of the natives of the Isthmus of Tehuantepec (a strip of lowlands running across southern Mexico from the Gulf to the Pacific Ocean) are typical of the ethnic values that give Mexico its singular character. Tehuana women are proverbial beauties, and no program of folkloric dance would be complete without a Zandunga or other Tehuana number.

Diego Rivera became fascinated with Tehuantepec during a visit in 1922, and Tehuana motifs remained in this work thereafter. *Dance at Tehuantepec* was painted in 1928, the year before Rivera married Frida Kahlo, who would herself adopt Tehuana fashions as her own manner of dress. One of two monumental works Rivera made in 1928 depicting the Zandunga (the other a fresco in the Court of Festivals at the Secretariat of Public Education in Mexico City), the

picture also shows Rivera's total assimilation of *indigenismo*, or the use of indigenous motifs to energize modern painting and separate Mexican art from that of other nations.

Rivera has managed to capture in oil much of the luminosity of fresco, which is augmented by the painting's large size. The solid, monumental forms within the composition, including the rather Cubist foliage and banana plants forming a canopy over the heads of the dancers, give the image both an architectonic and an organic character, as though nature itself were echoing the serene folk classicism of the dancers' poses and costumes. Indeed, everything about the picture is classical, both in that the design values originated in Greco-Roman antiquity and the sense that the scene is archetypical, defining a class of cultural experience.

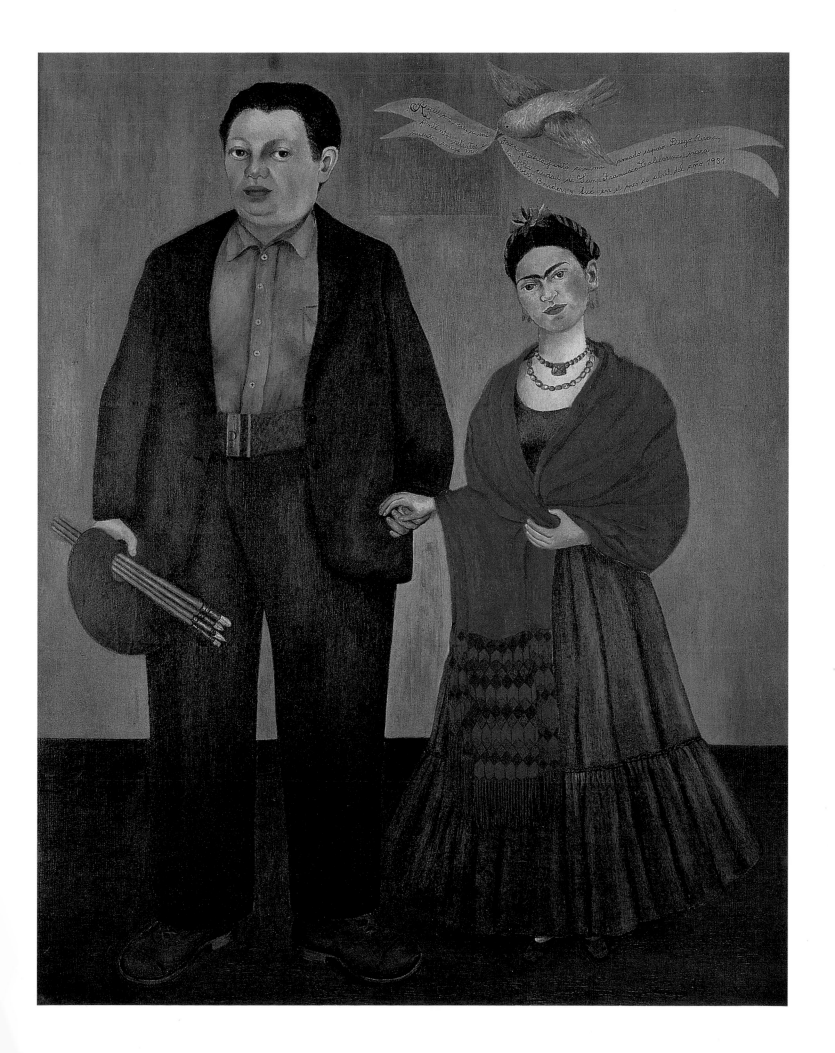

The Two Fridas
1939
Frida Kahlo (1907–1954)

Oil on canvas. 67 x 67 inches (170.2 x 170.2 cm).
Museo de Arte Moderno, Mexico City.

Pain and suffering were no strangers to Frida Kahlo. She was stricken with polio at age six and left with a withered right leg. At eighteen, a flimsy bus in which she was riding was destroyed in a grisly accident with a streetcar. She suffered a score of fractures, as well as dislocations and a crushed right foot. Worse, she also found herself impaled on a steel rod through her pelvis.

Somehow she survived, but the rest of her life would be a constant fight, with periods of relative health and mobility alternating with relapses of terrible suffering. She endured frequent hospitalizations, some thirty-five operations in twenty-nine years, confinement in plaster body casts and steel corsets, and eventually the need for a wheelchair—all leading to amputation and eventually, to her premature death in 1954. A particular sorrow was her inability to bear children; repeated attempts all ended in painful miscarriages or therapeutic abortions.

It was about the time of her childhood bout with polio that Kahlo began to create an imaginary companion. Teased and isolated because of her disability, her imaginary playmate offered humor and consolation. Many of her contemporaries, and Kahlo herself, subsequently spoke of a dual, or even multiple, personality. Furthermore, by necessity, any artist painting a self-portrait must at once become both the observer recording the image and also the thing observed, implying a dual role in even the most simple image. To this, we may add other dualities, such as masculine-feminine (Kahlo often exaggerated masculine characteristics such as a moustache in her self-portraits and is said to have been bisexual) and European-Indian (her father was German-Jewish, her mother a Mexican *mestizo*).

Kahlo's paintings are intensely biographical, and *The Two Fridas* is no exception. Details in the painting hint at loss: the literally broken heart of the "Victorian" Frida to the left, the blood spilling out in spite of the surgical clamp on the vein. This clinical touch reminds us of Kahlo's youthful desire to study medicine and recalls an earlier image, the *Henry Ford Hospital* of 1932, painted after a particularly traumatic miscarriage in Detroit, where her husband, Diego Rivera, was painting murals at the Art Institute. Indeed, it was Diego Rivera who eventually caused the "Victorian" Frida's heart to break. Although both Kahlo and Rivera had numerous affairs during their marriage, the years 1938 and 1939 found Kahlo increasingly independent and Rivera unusually distant. For reasons that are still not clear, the pair divorced, only to remarry in December 1940.

The Two Fridas was inspired by this new trauma. As Kahlo told a visitor in December 1939, the "Victorian" Frida represented the Frida that Rivera did not love, set alongside the Frida that he did (dressed as a Tehuana Indian and holding a miniature portrait of Diego Rivera as a child). Kahlo also associated the Tehuana Frida with her imaginary childhood companion, consoling her for her loss. But *The Two Fridas* far transcends its origins in sad personal events. In addition to a noble stoicism, the painting projects a calm self-reliance as the two women turn their back on the turbulent sky. It seems that the Tehuana Frida has life enough to replace the blood dripping from the veins of the rejected Frida. The stiff, hieratic figures, monumentally silhouetted against the clouds, are also curiously relaxed, and in this detail there is hope.

Like some Greek heroine, Frida Kahlo suffered beyond mortal endurance. But Kahlo had an advantage over Antigone: she could be her own Sophocles, creating a mythical self lifted to a higher plane in the realm of art and fantasy as a way of sublimating her real turmoil. Kahlo in effect translated herself into an empyrean of her own devising: the marvelous, powerful world of her unforgettable images.

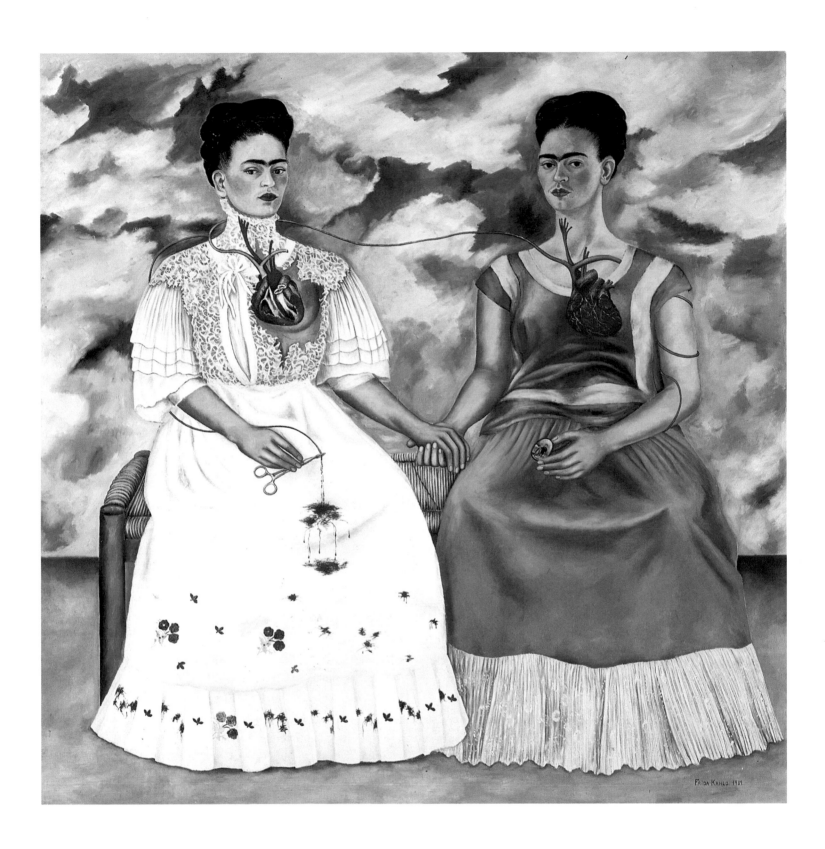

Self-Portrait with Monkey
1940
Frida Kahlo (1907–1954)

Oil on masonite. 21 x 16 3/4 inches (53.3 x 42.5 cm).
Private Collection.

As a self-portraitist, Frida Kahlo has almost no peers among her contemporaries; any comparison must go back to Dürer, Rembrandt, and Van Gogh. For Kahlo, self-portraiture became a career in itself, and most of her important works are in some way self-images. If we add portraits of the artist made by others, especially photographers, we see an incredible variety of moods and values: a love of life, naive innocence, dégagé sophistication, political activism, defiant existentialism, surreal fantasy, and above all, an awareness of the pain inherent in human life—sometimes accepted stoically, sometimes met with bitter tears.

Monkeys have a long history in European art. In fact, art is often called "the ape of Nature" because of its ability to imitate reality. Eighteenth-century masters liked to dress monkeys up as people in various professions to satirize the human condition, and *singeries* (from the French word for "monkey") were a common aspect of Rococo decoration. More importantly, the combination of monkeys and humans in exotic settings was found in the paintings of the Douanier Henri Rousseau, the French naive master and proto-Surrealist, whose art certainly influenced Kahlo.

In fact, Kahlo kept a number of monkeys as pets, including the exotically named Fulang-Chang, whom Frida included in a self-portrait of 1937, and Caimito de Guayabal ("piece of fallen fruit from the Guava patch"), whom Diego Rivera had brought as a present from a trip to the south of Mexico. The monkeys were surrogate children, alter egos, and fantasy companions not unlike the imaginary playmate she had created as a child. In *Self-Portrait with Monkey*, painted near the end of the period in which Kahlo and Rivera were divorced, the monkey (apparently Caimito) is clearly something else, a stand-in for Diego. Like the veins connecting The Two Fridas, the blood-red ribbons falling from Frida's hair wrap around her neck, then around the monkey's, binding the two together. Similarly, the monkey's paw seems to emerge from her hair as it wraps around her shoulder and neck. The paw is particularly ominous—black, curving, clawed, threatening strangulation—and the red ribbon overtly suicidal. It is as though Kahlo were saying that Rivera's absence was killing her as surely as though he had choked her or slit her throat.

Nevertheless, the mood that emerges is one of stoic victory, quiet acceptance, and calm. Indeed, by the end of the year, Frida and Diego were back together. If *Self-Portrait with Monkey* is any indication, however, it was a much stronger Frida Kahlo who remarried in December.

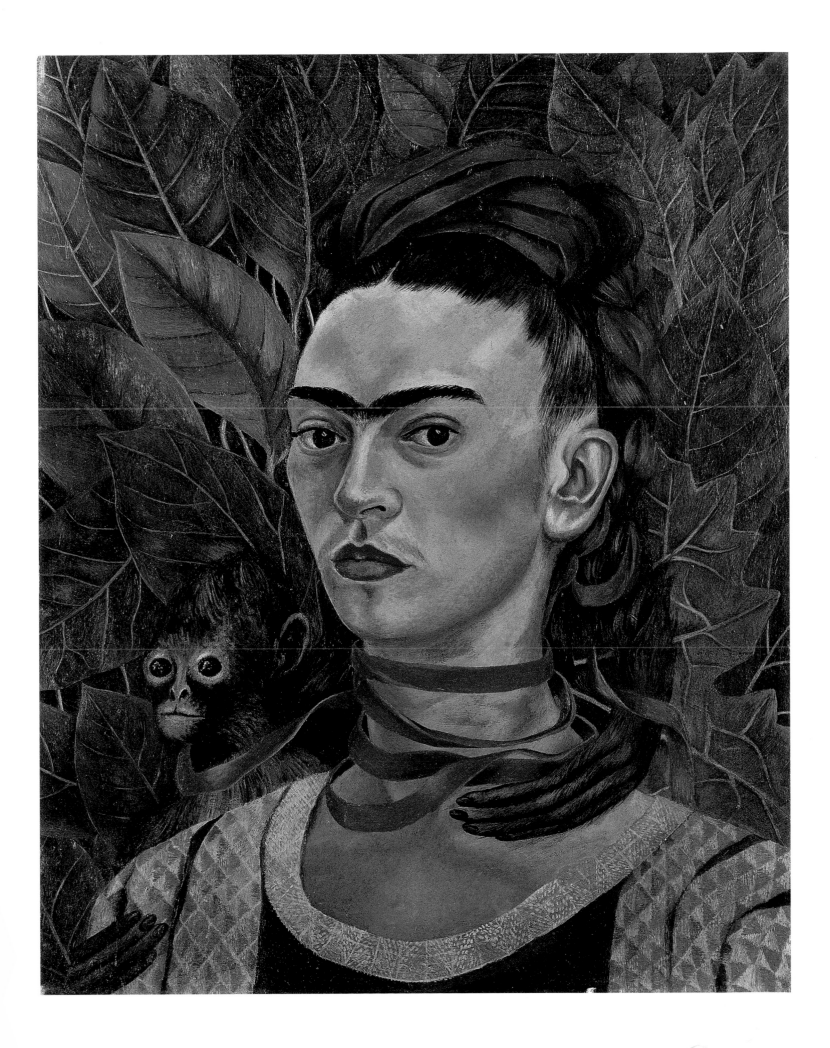

The Flautist
Signed and dated 1944
Rufino Tamayo (1899–1991)

Oil on canvas. 45 1/8 x 37 1/4 inches (114.6 x 94.6 cm).
Private Collection.

Youthful rebellion is an ancient leitmotif in human civilization, and artists are no exception to the rule. In the case of Diego Rivera and José Clemente Orozco, along with their younger allies David Alfaro Siqueiros and Juan O'Gorman (not to mention the entire international modernist movement), the rebellion was against the Old Master tradition, along with a strident attack on bourgeois culture in general. Rufino Tamayo's rebellion was of a quieter sort: he preferred to explore the realm of private expression and individual values in his art, rather than to jump on the bandwagon of socialist muralism.

Tamayo was born of Zapotec Indian descent at Oaxaca in 1899. Orphaned, he went to Mexico City in 1911 to live with an aunt who kept a fruit market, the memories of which would echo in his still life compositions. Sent to commercial school, he studied art in the evenings, eventually matriculating at the Fine Arts Academy of San Carlos from 1917 to 1921. In 1921, he was appointed head of the ethnographic section of the National Arhaeological Museum; and throughout the 1920s, also taught art in elementary schools and open air rural schools. He visited and exhibited in New York from 1926 to 1928, and he worked under Diego Rivera at the reformed Academy, now called the National School of Fine Arts, from 1928 to 1929 where he taught María Izquierdo. Their subsequent four-year relationship was an artistic collaboration as well as a romantic affair. In 1934, Tamayo married the pianist Olga Flores Rivas. They moved to New York in 1936, with Tamayo remaining active there until 1948. After his first trip to Europe in 1949, he divided his time between Paris and Mexico.

In an interview with Emily Genauer, Tamayo recalled his reaction to the muralists's doctrines:

> The trouble was that the [mural] painters portrayed only a surface nationalism. They painted the facts of Mexican history and culture, all leading to the facts of the revolution. But revolution is not a Mexican phenomenon. It happens all over the world. I'm not opposed in theory to what they did. It was natural for them. But I myself felt something beyond that. I was a rebel, not against the revolution, but against the Mexican mural movement which was conceived to celebrate it. . . . I think in terms of universality. Art is a way of expression that has to be understood by everybody, everywhere. It grows out of the earth, the texture of our lives and experiences.

In fact, Tamayo's imagery is intensely Mexican, blending the ethnographic interests of *indigenismo* with the study of Prehispanic art and an ability to find the universal in the details of everyday life. Even his still lifes, and the still life details in his figure compositions, such as the bowl of fruit at the lower right in the present example, have deep roots in both colonial and nineteenth-century Mexican art. But the style in which Tamayo has chosen to express his themes is international, a personal assimilation of European modernism with marked influences from Pablo Picasso and Paul Klee.

The Flautist was created towards the end of a long period during which Tamayo employed a series of solid, earthen figures, before he began breaking up the figure into the all-over compositions of his later works. Although classically conceived and presented as isolated and lost in the reverie of his music, the flautist is imbued with a distinct personality, perhaps reflecting Tamayo's efforts in portraiture following his marriage to Olga. Although highly abstract, the work is not without naturalistic touches, such as the way the flautist pushes his head back in order to breathe between notes. Since an oil painting must by necessity be silent, choosing this moment allows Tamayo to maintain a type of artistic propriety while still implying the sound of the flute.

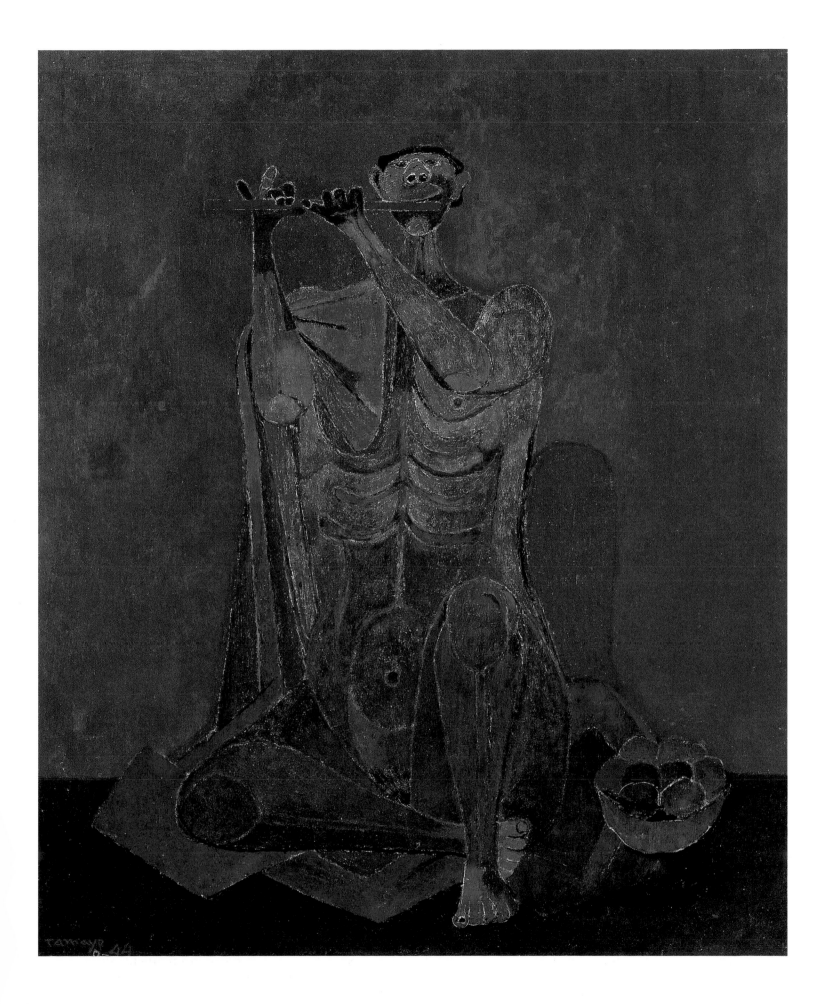

The Bicycle Race, Texcoco
1938
Antonio M. Ruiz (1897–1964)

Oil on canvas. 14 ½ x 16 ½ inches (36.8 x 41.9 cm).
Philadelphia Museum of Art. Purchased with the Nebinger Fund.

Antonio Ruiz represents a group of Mexican artists in the 1930s and 1940s who brought a deceptively naive but in fact highly modern style to gently satirical representations of everyday life. (The painter, ethnologist, archaeologist, and dance administrator, Miguel Covarrubias, also falls into this category.) Although related to *indigenismo*, Ruiz's art eschewed overtly Indian or ethnographic subjects, and his humor and naiveté separate him from the earnest, socialist woodcuts of the Taller de Gráfica Popular.

Born in Texcoco in 1897, Ruiz initially studied painting from 1914 to 1916 at the Academy but completed his degree in architecture and scenic design. After 1921, he worked as a drawing teacher in elementary schools, moving in 1932 to a professorship of architecture (technical models) and eventually, in 1938, of scenography. In 1942, he became founding director of the Escuela de Pintura y Escultura "La Esmeralda."

Like his friend Frida Kahlo (who taught at La Esmeralda, along with Diego Rivera), Ruiz embraced the traditions of Mexican folk art and genre painting. In *The Bicycle Race*, we also find a clear resonance with the works of European naive painters, such as the Douanier Henri Rousseau. Here, Ruiz has returned to his boyhood hometown, Texcoco, to capture the spirit of a country fair. The confident power of the winning rider, the vain struggle of the runner-up, the intense concentration of the judges with their stopwatches, the decorum of the grandstand invitees, the boisterous joy of the children (including one whose new bike may mean he too will participate in a future race)—all of these details are captured lovingly. Critic Sabine Rewald has counted eighty-three human faces (and a handful of animals) shaded by the swirling forms of the jacaranda trees above.

Indeed, the trees are a telling detail revealing much about Ruiz's methods. Like Rousseau and the Surrealists who followed, Ruiz often uses natural motifs in an isolated, dreamlike context as a type of psychological "massage," conveying emotional qualities directly to the viewer. Although the trees may seem a bit menacing, their lively forms fill the composition with an ebullience typical of the type of social event depicted. Ruiz's childlike, naive rendering camouflages a far more sophisticated artistic communication.

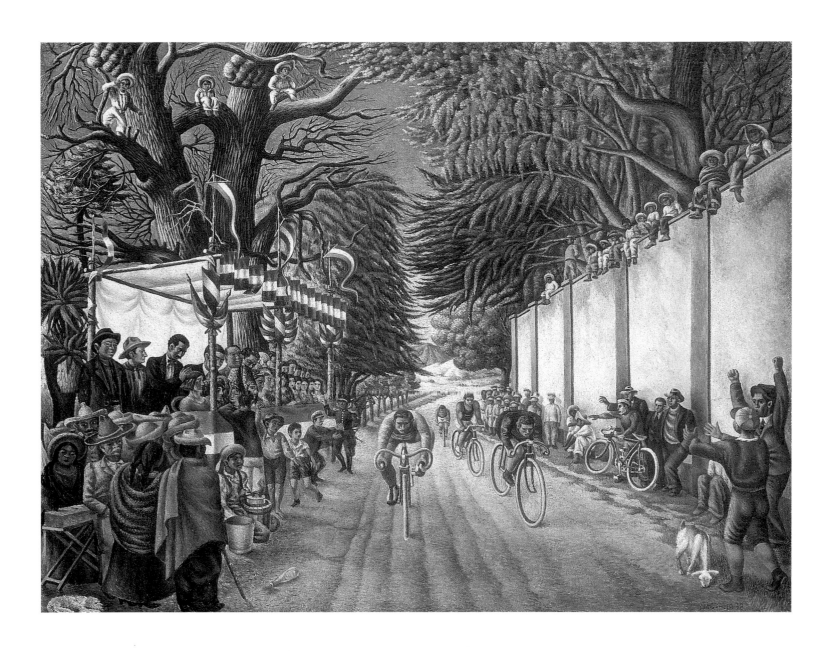

Family Portrait (My Nieces)
1940
María Izquierdo (1902–1955)

Oil on plywood. 55 ¼ x 37 ¼ inches (140.3 x 94.6 cm).
Museo de Arte Moderno, Mexico City.

One phenomenon that distinguishes art of the twentieth century from that of previous centuries is the emergence of women as great masters at the center of artistic movements, not at the periphery. In Mexico, the 1930s saw the development of a number of exceptionally talented women artists such as Frida Kahlo, the photographer Lola Alvarez Bravo, and María Izquierdo. No longer content subordinating their own artistic careers to those of their menfolk, these and other women artists began to bring new perspectives to modern art.

María Izquierdo was born in San Juan de los Lagos, Jalisco, in 1902. She was not brought up by her parents but, rather, by relatives in one rural town after another. In 1917, at the age of fourteen, her family arranged a marriage to Colonel Cándido Posadas, a provincial army commander, with whom she had three children and moved to Mexico City in 1923. She left the marriage in 1927 and soon began studying art at the National School of Fine Arts (formerly the Academy of San Carlos). Diego Rivera was then director, and the young Rufino Tamayo one of the instructors. Tamayo became Izquierdo's teacher and soon, her lover as well; their relationship and artistic collaboration lasted from 1929 to 1933. Rivera remained an important supporter of Izquierdo's career, except for when, in 1945, she prepared a project for a mural decoration in the Palacio del Gobierno. Rivera and Siqueiros refused to approve the project, citing Izquierdo's lack of experience in fresco. (One suspects that wall painting was, in their minds, a "male" thing, as opposed to the "female" intimate subjects, still lifes, and family portraits in Izquierdo's oeuvre.) In 1938, Izquierdo became involved with Raúl Uribe Castillo, a Chilean diplomat who was also a painter. Their marriage, from 1944 to 1953, brought new circles of patronage into Izquierdo's career.

Although she eschewed extensive formal training in art, preferring to remain "self-taught," Izquierdo cultivated extensive artistic influences. A hard worker, Izquierdo mounted an impressive series of one-woman exhibitions throughout her career, beginning with one organized by Rivera in 1929 at Mexico City, followed by another in New York. In the mid-1930s, Izquierdo and Lola Alvarez Bravo rented a joint studio in Mexico City, a symbol of their intention to thrive as independent artists.

Izquierdo was, of course, also a mother, and one with suffocating memories of a lonely, parentless childhood. In this *Family Portrait (My Nieces)*, Izquierdo portrays herself with two of her nieces, but while the girls are dressed in the fashions of the 1930s or 1940s, Izquierdo has clad herself in turn-of-the-century provincial attire. Although Izquierdo, like many other Mexican women (compare Frida Kahlo's use of Tehuana costumes), could maintain dépassé provincial dress as a gesture of *mexicanismo*, something else is at work here, which relates the image to others of Izquierdo's childhood, such as one of herself as a child with her aunt (principle caregiver) and a playmate.

What is more, the niece in red resembles Izquierdo's images of herself in childhood, and the picture may also relate in some general way to Izquierdo's own memories of motherhood, although her children were fully grown by 1940. Izquierdo's use of the clash of fashions as a means of collapsing time has not been sufficiently studied, but may have intervened in other compositions, as well, such as *The Little Girl Who Did Not Care* of 1947 (Galeria de Arte Moderno, Mexico City). Family memories, old photographs, dreams, and fantasy thus begin to merge in Izquierdo's works, a process typical of much Surrealist art. In *Family Portrait (My Nieces)*, the jungle background, with its exotic flowers and banana trees, adds to the surreal, dreamlike atmosphere of the picture, augmented by Izquierdo's bold colors and naive folk art techniques.

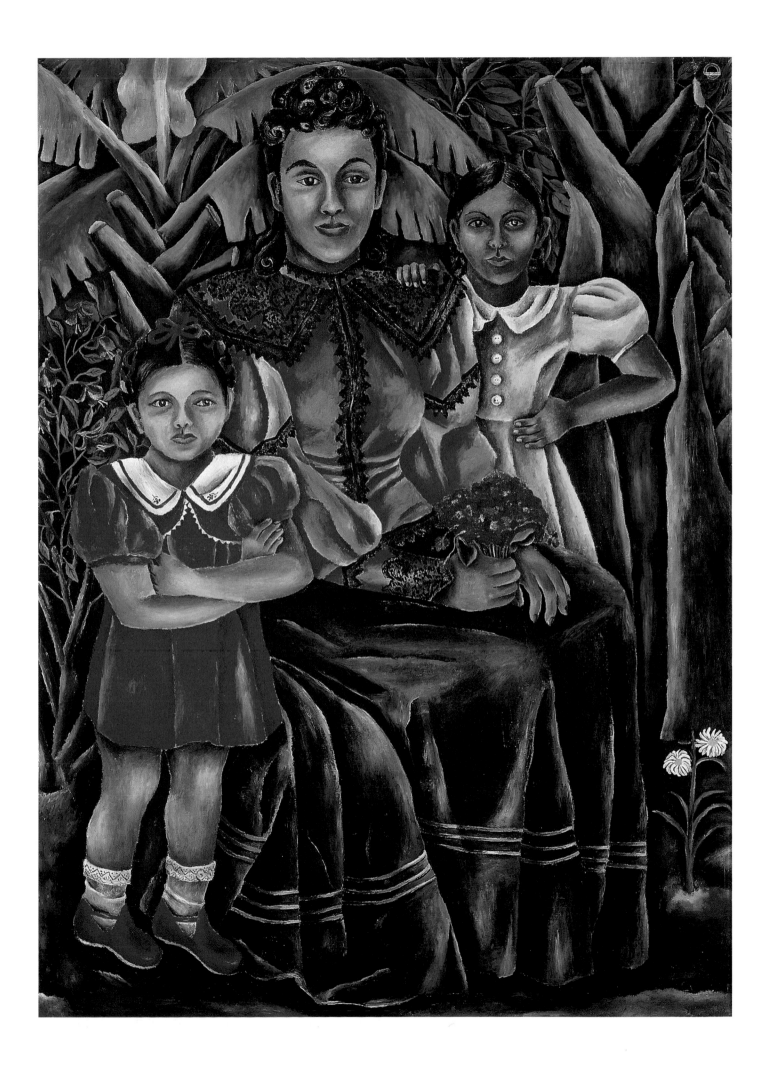

La Dádiva
Signed and dated 1973
Carlos Mérida (1891–1984)

Polished acrylic on parchment mounted on panel. 31 ¾ x 24 inches (88.7 x 60.8 cm).
Private Collection.

Twentieth-century Mexican painting, like painting in the United States before World War II, in general lacks an otherwise extremely important current in modern art: pure abstraction. Instead, following the lead of the muralists, Mexican painters have applied modernist techniques to figurative compositions, so that they can communicate complex ideas to large audiences.

Carlos Mérida is an exception to this trend. Born in Guatemala City in 1891, Mérida trained at the Institute of Arts and Crafts there and at Quetzaltenango. From 1910, he was in Paris, where he worked with Kees van Dongen and Amadeo Modigliani, as well as Anglada-Camarasa, Piet Mondrian, Pablo Picasso, and Diego Rivera. He returned to Guatemala in 1914, but went to New York in 1917, moving to Mexico City in 1919, after his marriage to Dalila Gálvez. He worked with Rivera in 1921 and was part of the muralist syndicate beginning in 1922.

In 1927, Mérida returned to Paris and, under the influence of friends such as Paul Klee and Joan Miró, not to mention Wassily Kandinsky, moved away from figurative compositions in favor of a purely abstract, Surreal style. Later, influences from Fernand Léger, Josef Albers, and Bauhaus constructivism would appear in his works. An international artist, Mérida was also active in Texas, where he taught at North Texas State Teachers College at Denton (near Dallas) from 1941 to 1942. He was in New York in 1944 and returned to Mexico in 1949, but made another trip in 1950 to Europe, where he studied Venetian mosaic techniques. Among his later works were mural projects in Mexico City, Guatemala City (Civic Center, 1956), and San Antonio, Texas (*The Confluence of Civilizations*, in mosaic, 1968). Mérida has been an extremely important role model for other Mexican artists active in purely abstract modes, such as Gunther Gerzso and Vincente Rojo.

Mérida's works from the 1960s and 1970s often have a heavy black armature of narrow vertical triangles, almost like a series of "M"s or "W"s, into which color units and fragments of figures or objects are set in typical Synthetic Cubist technique. In the present example, the colorful oval and circular forms with soft auras are borrowed from Kandinsky but set into a much bolder overall composition, almost like a great chord blasted out by a full orchestra. At the same time, the diagonal forms have been cropped so that the lines leaning to the right dominate, creating a rippling movement from left to right. A long lifetime of abstract experimentation has come to fruition in this finely tuned but extremely dynamic image.

The Spanish word *dádiva* means "a present, gift, grant, contribution," and indeed, the lateral thrust of the composition seems to suggest that the dark-skinned figure at the left is offering something— perhaps a set of pipes, the gift of music?—to the lighter-skinned figure at the right. The lighter-skinned figure also seems to be dressed in more subdued tones, whereas the field of colors around the darker-skinned figure conjures up multi colored *sarapes* or other indigenous textiles. Certainly, the darker-skinned figure dominates the composition, and, in a general way, we may assume that the underlying idea is a celebration of the New World's contribution to human culture.

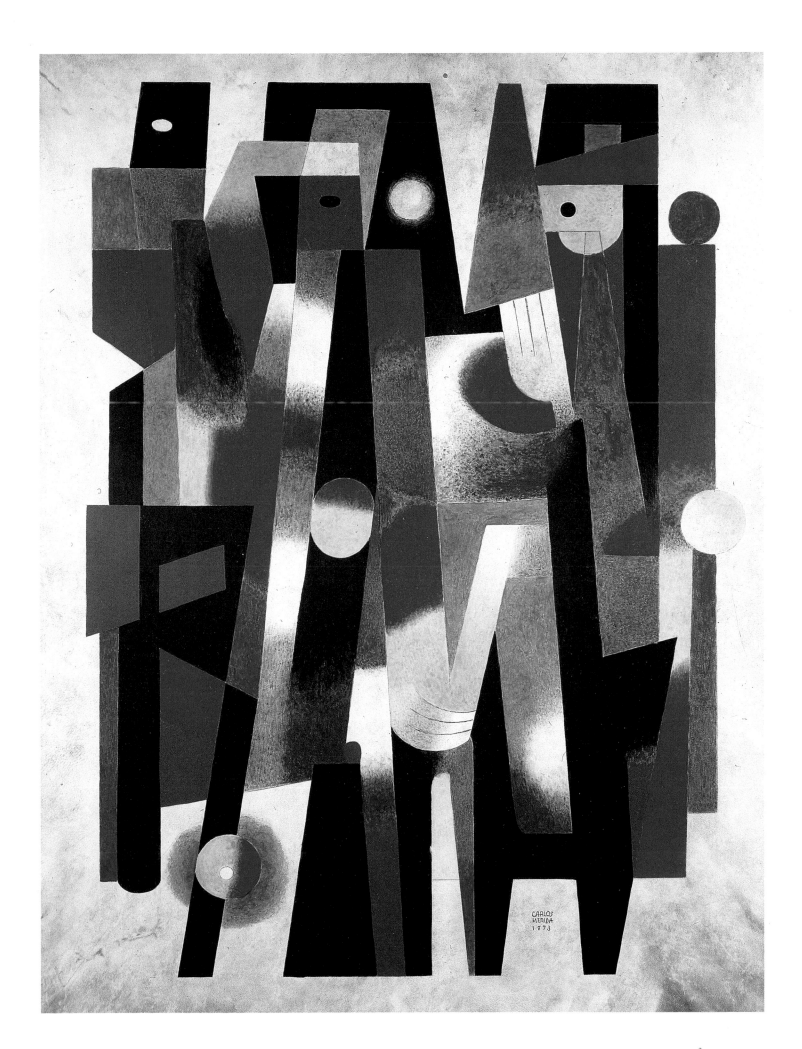

Green-Blue-White-Red
Signed and dated 1976
Gunther Gerzso (b. 1915)

Oil and fine sand on masonite. 11 ³⁄₈ by 13 ½ inches (28.9 x 34.3 cm).
Private Collection.

Born in Mexico of Hungarian and German parents, Gunther Gerzso was taken to Europe in 1922, and settled in Switzerland in 1927 with his uncle, the art historian and antiques dealer, Hans Wendland. Gerzso returned to Mexico in 1931. He attended the German School and, from 1933, worked as a scene and costume designer. From 1935 to 1940, he was the stage designer at the Cleveland Playhouse, and also studied painting in New York. He married a United States musician, Gene Rilla Cady, in 1940, and the following year they returned to Mexico, where Gerzso designed for both the stage and cinema, subsequently working on more than 250 films with directors such as Luis Buñuel and John Ford. In 1944, he also became attached to the Mexican Surrealist group, including Remedios Varo and Leonora Carrington, and came under the particular influence of Yves Tanguy, whose stark landscapes peopled with abstract biomorphic forms largely influenced international cinema and stage design. During the 1950s and early 1960s, Gerzso's works became more fully abstract, under the influence of renewed studies of Cubist, ancient Greek, and Prehispanic art, not to mention developments in the United States, where Gerzso often exhibited.

Gerzso's mature works are examples of what is called "nonfigurative abstraction," in which the artist communicates by pure color and form alone. In generational terms, Gerzso stands midway between Carlos Mérida (1891–1984), who seldom left representational elements out of his compositions, and younger nonfigurative painters such as Vincente Rojo (b. 1932), who create compositions with no intent to depict anything.

In Gerzso's case, a type of illusion is intended; something is being depicted, but that something is not the ordinary world. Rather, forms we may relate to heavy sheets of colored metal or thick felt slide over one another or peel away to create compositional harmonies. The effect is static, as though the forms had jammed together like pack ice, but there is always a sense of tension, as large forms lock against a series of smaller fragments, the whole threatening to explode at any moment. In keeping with his surrealist background, Gerzso manipulates textures, as in the present example, in which sand has been added to the paint in order to give a psychological "massage" to the viewer (compare the use of sand in the compositions of European Abstract Surrealists, such as Jean Dubuffet). A picture by Gerzso is always luminously colored, compositionally intricate, complex in texture, yet classically composed, conveying a sense of heavy, permanent values that dominate the fragmenting static of everyday existence yet are undeniably energized by the flux of life.

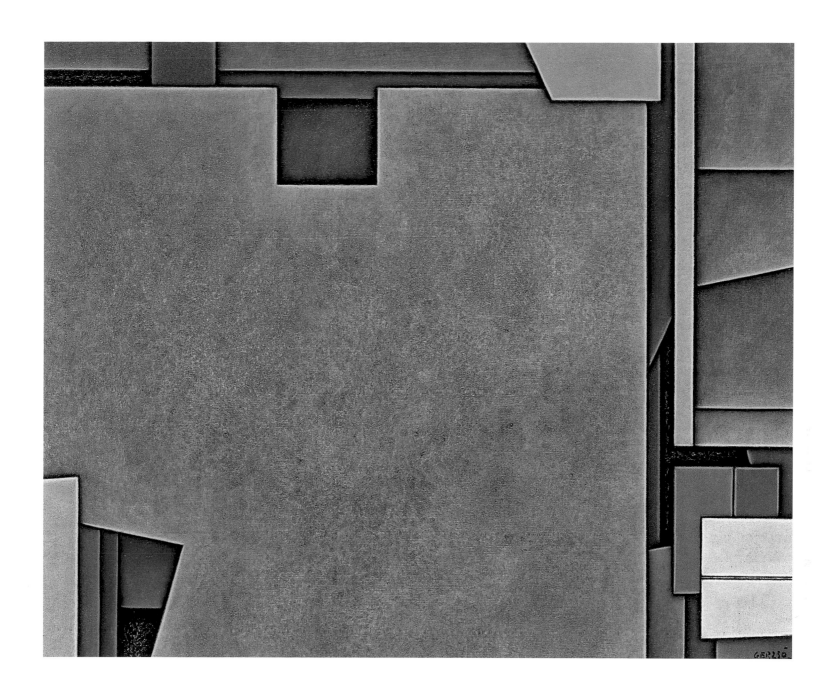

The Angry Cat
1975
Francisco Toledo (b. 1940)

Oil and sand on canvas. 47 ¼ x 39 ¼ inches (120 x 99.5 cm).
Private Collection.

Among the many things that modern, abstract art does very well is express an idea by transforming the depicted motif into the idea's visual equivalent. Freed from the obligation to imitate outer reality precisely, abstract art can communicate directly, grabbing the viewer's subconscious along with his or her intellect. In an Old Master painting of, for example, an angry tomcat, the artist may be able to show the animal with an arched back, fur standing on end, snarling mouth, and focused eyes, but any direct communication of how the animal feels relies on agitated brushwork, color contrasts in the background, or similar essentially abstract devices.

In Francisco Toledo's *The Angry Cat*, an idea (the emotion of anger) and an abstracted physical description (here, of a cat) are given equal weight. The picture expresses anger as a network of triangular shapes produced by scratchy white markings that cover the cat's body, and by the orange glow on the face. The sharp triangularity is repeated in the patch of rug or grass on which the animal stands, and the glow also appears at the bottom of the composition, making the overall effect even more disconcerting, as though the animal and its patch of turf are somehow levitating. The angry animal is indeed a cat, but the anger is what drives the viewer's response.

Francisco Toledo was born in 1940 in the Indian town of Juchitlán near Oaxaca; like Rufino Tamayo, he is of Zapotec origin. He studied graphic arts in Mexico City, then, in 1960, began a five-year stay in Paris, with extensive travels throughout Europe.

(His career had been far-ranging from the outset, his first one-person show held in Fort Worth, Texas, when he was only nineteen.) He returned to Mexico in 1965, but spent a brief period working in New York in 1977. Toledo now spends his time in Ixtopec and Juchitlán, Oaxaca, Mexico City, and Paris.

Considering Toledo's international perspective, it is not surprising that his works are most closely allied with European Abstract Surrealism, having been markedly influenced by the creations of artists such as Paul Klee, Joan Miró, and Jean Dubuffet. His relationship with American Abstract Expressionism and its aftermath, as for example in the works of Willem de Kooning, Mark Tobey, and Jasper Johns, is more complex. Among the Mexicans, Toledo is obviously closest to his fellow-Oaxacan, Rufino Tamayo, especially to Tamayo's luminous, pastel later works and their obvious resonance with the art of Paul Klee.

Klee, Miró, and Dubuffet often brought a sense of humor to art, and Toledo does so as well. His works often have a light, fantastic touch that can suddenly flip into something quite menacing. And interestingly, given that his style is anything but provincial, he still incorporates many indigenous Mexican motifs into his art. The result is a dynamic mixture of local and international values, of the particular and the general. A presumably Mexican, angry cat becomes all tomcats with their backs up, an emblem of aggressive anger. He is also isolated, ineffectual, just a little bit ridiculous; Toledo allows us to smile at the folly of anger even as he epitomizes it.

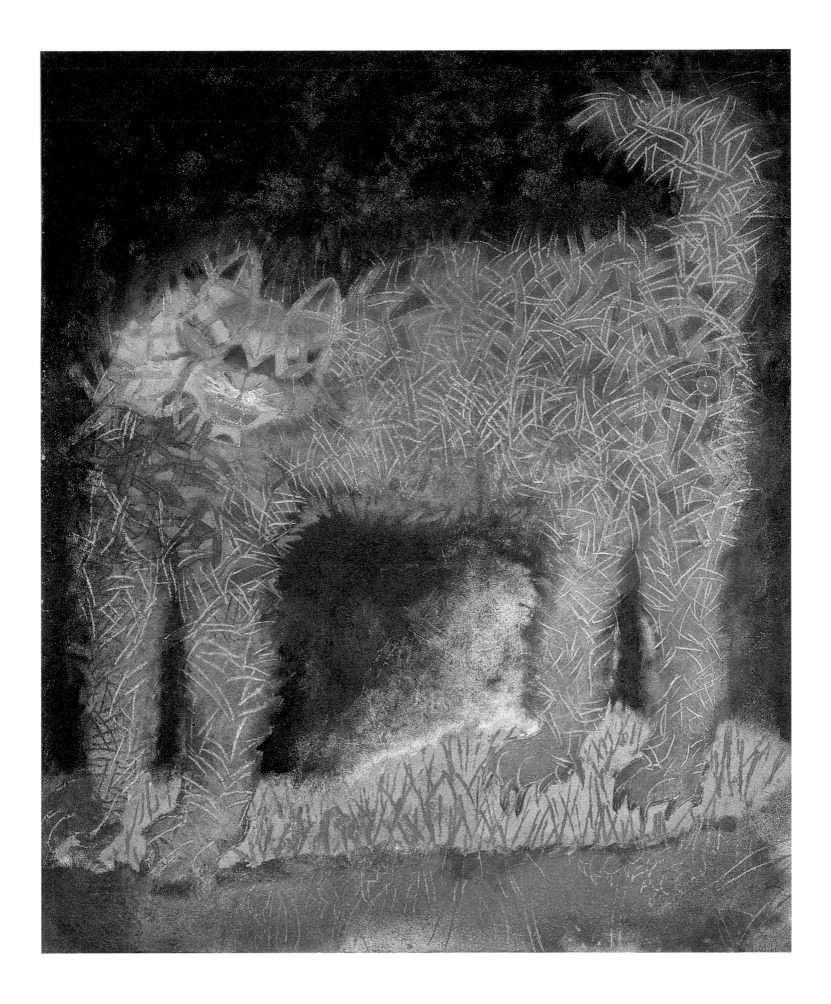

Ex voto (Self-Portrait with the Virgin of Guadalupe)
1987
Nahum B. Zenil (b. 1947)

Mixed media on paper. 20 7/8 x 15 inches (53 x 38.1 cm).
Private Collection.

Alienation is a common theme in twentieth-century art, whether it is the general, existential alienation of the individual faced with an absurd universe, the political repulsion of those confronting an unjust society, the social isolation of coming from the country to the city, the spiritual disorientation of the ex-believer for whom the old truths are no longer valid, or the rejection and guilt felt by those whose sexual orientation falls outside the norms and mores of conventional society. Modern artists have offered a wide range of responses, from enlisting their talents in the services of radical political causes, including those of the Mexican revolution, to focusing intensely on the self. Nahum B. Zenil is among those choosing the latter path.

Nahum Barnabé Zenil was born at the village ranch of El Tecomate near Chicontepec in the Huasteca region of Veracruz in 1947. Even in the 1950s, El Tecomate was without modern roads and could become completely isolated in the rainy season. Zenil grew up with his mother and grandmother, while his father, a local schoolteacher, lived elsewhere. At the age of twelve, Zenil went to Mexico City to enroll in the National Normal School for Teachers at Mexico City. He graduated in 1964 and spent the next twenty years as a teacher. In addition to his teaching duties, Zenil enrolled in 1968 in the "La Esmeralda" art academy (the same school founded in 1942 by Antonio Ruiz), graduating in 1972. Thereafter, he pursued a successful second career as an artist, until, in 1984, he was able to quit teaching and devote himself full-time to art.

An important inspiration, for Zenil as for other so-called neo-Mexicanists, has been the art of Frida Kahlo. For example, the heart at the middle of *Ex voto* is obviously related to the hearts in *The Two Fridas*. In other pictures, the parallel is quite extensive, including both artists's obsessions with self-portraiture, Surrealist transformations, and dreamlike imagery.

An "ex voto" is an act or object created in response to a vow. In many Mexican churches small paintings on tinned steel sheets record the miraculous intervention of Christ, the Blessed Virgin, and other saints in the lives of individuals. Typically, the person commissioning the ex voto has been saved from some calamity by a fervent prayer to the Virgin, and in recognition of the prayer's being heard, the ex voto is presented to the church. A traditional ex voto is therefore a narrative, giving testimony to a mighty act of salvation. A legend at the bottom of each image recounts the event in words as well as pictures.

The lengthy inscription written across the lower right of Zenil's *Ex voto* recounts his personal history and (among other information), his praying to the Virgin of Guadalupe, the central pious cult of Mexican Catholicism. Zenil maintains his devotion to the Blessed Virgin, but with his own individual twists: for example, a careful inspection of *Ex voto* reveals that, instead of the usual cherub supporting the image of the Virgin, Zenil has inserted a tiny self-portrait, beard and all.

But from what threat has Zenil escaped? The long knife thrust into the heart by an anonymous hand might be taken to refer to ill health, but the hand may be the artist's own. As the inscription implies, Zenil's problem was more chronic than acute, and his salvation from a potentially deadly alienation bound up with his artistic career. Raised in a suffocating rural hamlet, seizing on (his father's) career as a way out, discovering his talents in painting and drawing, finding a society that could accept his homosexuality, then finally achieving success as an artist, Nahum B. Zenil has a lot to be grateful for. His audience can also share this gratitude, since his rescue (or self rescue) has provided so many insightful, beautiful works. Focusing on himself, Zenil has achieved a profound universality.

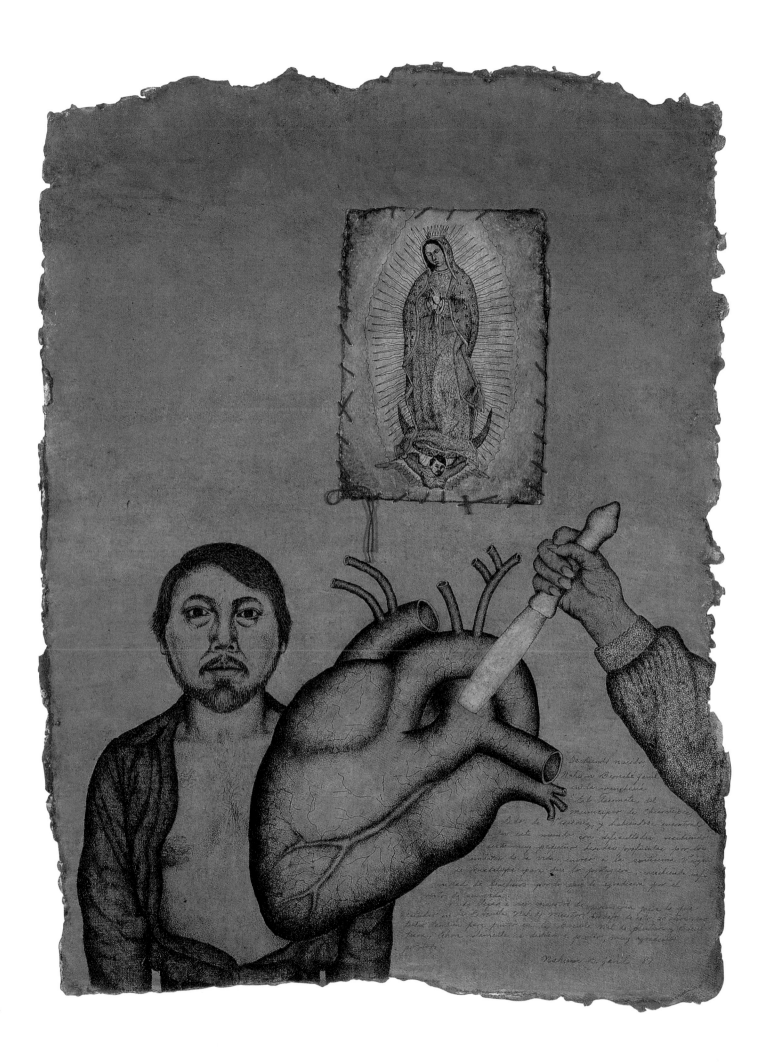

Bibliography/Suggestions for Further Reading

Ades, Dawn (with Guy Brett, Stanton Loomis Catlin, and Rosemary O'Neill), *Art in Latin America: The Modern Era, 1820–1980* (New Haven and London, 1989).

Azuela, Alicia, *Diego Rivera en Detroit* (Mexico City, 1985).

Bantel, Linda, and Marcus B. Burke, *Spain and New Spain: Mexican Colonial Arts in their European Context*, (exhibition catalogue, Art Museum of South Texas, Corpus Christi, 1979).

Billeter, Erika, et ali, *Images of Mexico: The Contribution of Mexico to Twentieth Century Art* (exhibition catalogue, Schirn Kinsthalle Frankfurt and Dallas Museum of Art, 1987).

Burke, Marcus B., *Pintura y escultura en Nueva España: El Barroco* (Mexico City, 1992).

Charlot, Jean, *Mexican Art and the Academy of San Carlos, 1785–1915* (Austin, Texas, 1962).

Elliott, David, et al, *Orozco 1883–1949* (exhibition catalogue, Museum of Modern Art, Oxford, England, 1980).

Fernández, Justino (Joshua C. Taylor, translator), *A Guide to Mexican Art* (Chicago and London, 1969).

Genauer, Emily, *Rufino Tamayo* (New York, 1974).

Goldman, Shifra M., *Contemporary Mexican Painting in a Time of Change* (Austin and London, 1981).

Herrera, Hayden, *Frida: A Biography of Frida Kahlo* (New York, 1983).

Hurlburt, Lawrence P., *The Mexican Muralists in the United States* (Albuquerque, 1989).

Kubler, George, and Martin Soria, *Art and Architecture in Spain and Portugal and their American Dominions, 1500–1800* (Baltimore, 1959).

Lafaye, Jacques, *Quetzalcóatl and Guadalupe: The Formation of Mexican National Consciousness, 1531–1813* (Chicago and London, 1976).

Metropolitan Museum of Art, New York, *Mexico: Splendors of Thirty Centuries* (exhibition catalogue, New York, 1990).

Miller, Mary Ellen, *The Art of Mesoamerica: From Olmec to Aztec* (second edition, London and New York, 1996).

Schiele, Linda, and Mary Ellen Miller, *The Blood of Kings: Dynasty and Ritual in Maya Art* (exhibition catalogue, The Kimbell Art Museum, Fort Worth, 1986).

Sullivan, Edward J., et al, *Latin American Art in the Twentieth Century* (London, 1996).

Sullivan, Edward J., and Clayton C. Kirking, Nahum B. Zenil: *Witness to the Self / Testigo del Ser* (exhibition catalogue, The Mexican Museum, San Francisco, 1996).

Toussaint, Manuel, *Pintura Colonial en México* (Mexico City, 1965, 1982).

Toussaint, Manuel, *Arte Colonial en México*, translated and edited by E. Wilder Wiesmann, *Colonial Art in Mexico* (Austin 1967).

Tovar de Teresa, Guillermo, *Pintura y escultura en Nueva España (1557–1640)* (Mexico City, 1992).

Weismann, Elizabeth Wilder, *Art and Time in Mexico: From the Conquest to the Revolution* (New York, 1985).

Index

Page numbers in *italics* indicate illustrations.

Photo Credits

Page 19, Danielle Gustafsom/Art Resource, New York; page 21, Scala/Art Resource, New York; page 23, © 1986 The Metropolitan Museum of Art, New York. Photograph by Lee Schecter; page 25, Werner Forman/Art Resource, New York; page 27, (left) Werner Forman/Art Resource, New York, (right) © The British Museum, London; page 29, Scala/Art Resource, New York; page 31, Giraudon/Art Resource, New York; page 33, Werner Forman/Art Resource, New York; page 35, Michael Zabe/Art Resource, New York; page 37, Werner Forman/Art Resource, New York; page 45, Musée des Jacobins, Auch, France. Photograph by Jacques Mitelman. All rights reserved. Page 47, photograph by Carlos Alcázar S.; page 53, photograph by Carlos Alcázar S.; page 55, © 1990 The Metropolitan Museum of Art, New York; pages 56/57, © 1990 The Metropolitan Museum of Art, New York; page 59, Museo Franz Mayer, Mexico City. Photograph by Jorge Vertíz G.; page 61, Museo Franz Mayer, Mexico City. Photograph by Jorge Vertíz G.; page 65, photograph by Carlos Alcázar S.; page 67, photograph by Carlos Alcázar S.; page 69, photograph by Carlos Alcázar S.; page 71, Schalkwijk/Art Resource, New York; page 73, Art Resource, New York; pages 74/75, courtesy Sotheby's, Mexico City. Photograph by Jesús Sanchez Uribe; page 77, courtesy Sotheby's, New York; page 79, Giraudon/Art Resource, New York; page 81, © 1997 The Detroit Institute of Arts; page 83, courtesy Sotheby's, New York; page 85, © 1998 The Museum of Modern Art, New York; page 87, courtesy of and © 1989 the Trustees of Dartmouth College. Photograph by Jeffrey Nintzel; page 89, Schalkwijk/Art Resource, New York; page 91, © 1998 The Museum of Modern Art, New York; page 93, Schalkwijk/Art Resource, New York; page 97, Schalkwijk/Art Resource, New York; page 99, Art Resource, New York; page 101, courtesy Sotheby's, New York; page 105, Schalkwijk/Art Resource, New York; page 107, courtesy Sotheby's, New York; page 109, courtesy Mary-Anne Martin/Fine Art, New York; page 111, courtesy Mary-Anne Martin/Fine Art, New York; page 113, courtesy Mary-Anne Martin/Fine Art, New York.